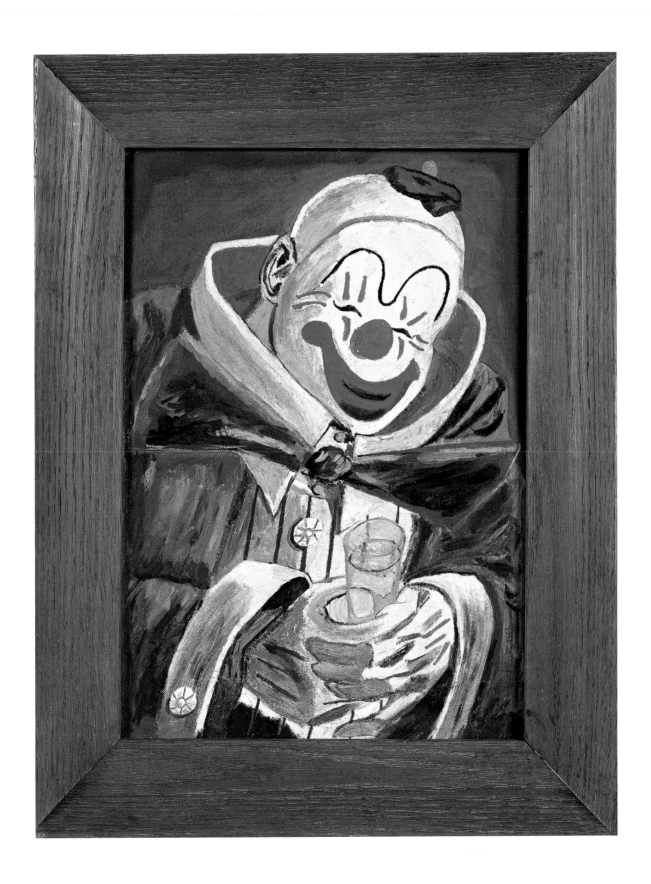

AFTERWORD BY **ROBERT BERMAN**

CLOWN PAINTINGS

EDITED AND WITH AN INTRODUCTION BY
DIANE KEATON

a lookout book/**powerHouse Books**
New York, New York

COMMENTARY BY

★ WOODY ALLEN ★ DAN AYKROYD ★

★ ROSEANNE CHERRI BARR ★

★ CANDICE BERGEN ★ SANDRA BERNHARD ★

★ CAROL BURNETT ★ CHEVY CHASE ★

★ LARRY DAVID ★ ELLEN DEGENERES ★

★ DANNY DEVITO ★ PHYLLIS DILLER ★

★ CARRIE FISHER ★ WHOOPI GOLDBERG ★

★ BOB GOLDTHWAIT ★ GOLDIE HAWN ★

★ ERIC IDLE ★ DON KNOTTS ★ LISA KUDROW ★

★ NATHAN LANE ★ JAY LENO ★ JERRY LEWIS ★

★ GARRY MARSHALL ★ STEVE MARTIN ★

★ HAROLD RAMIS ★ PAUL REUBENS ★

★ MICHAEL RICHARDS ★ JOAN RIVERS ★

★ GARRY SHANDLING ★ MARTIN SHORT ★

★ BEN STILLER ★ DICK VAN DYKE ★

★ JOHN WATERS ★ ROBIN WILLIAMS ★

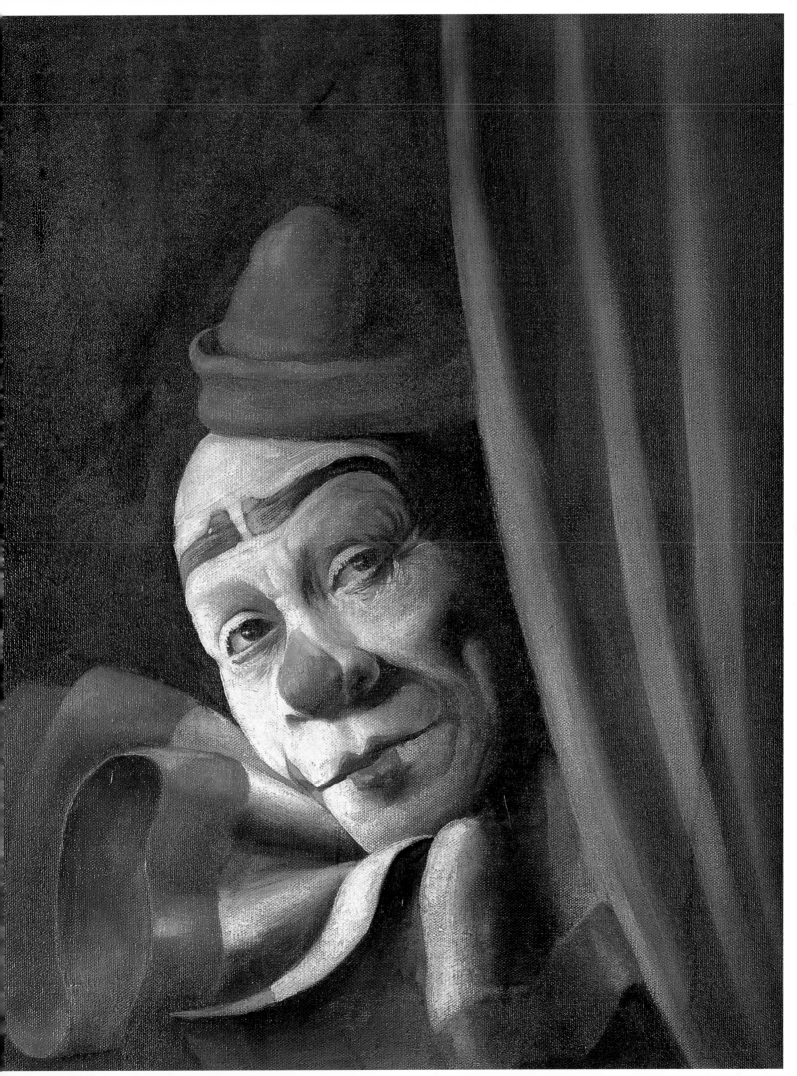

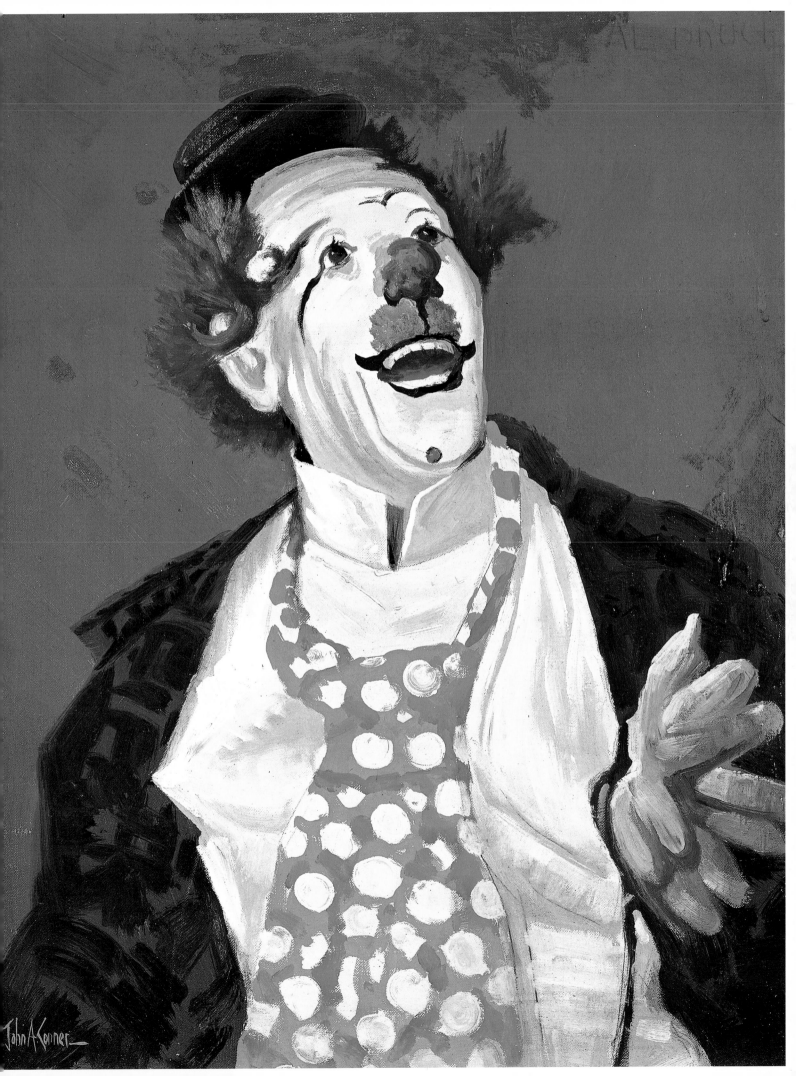

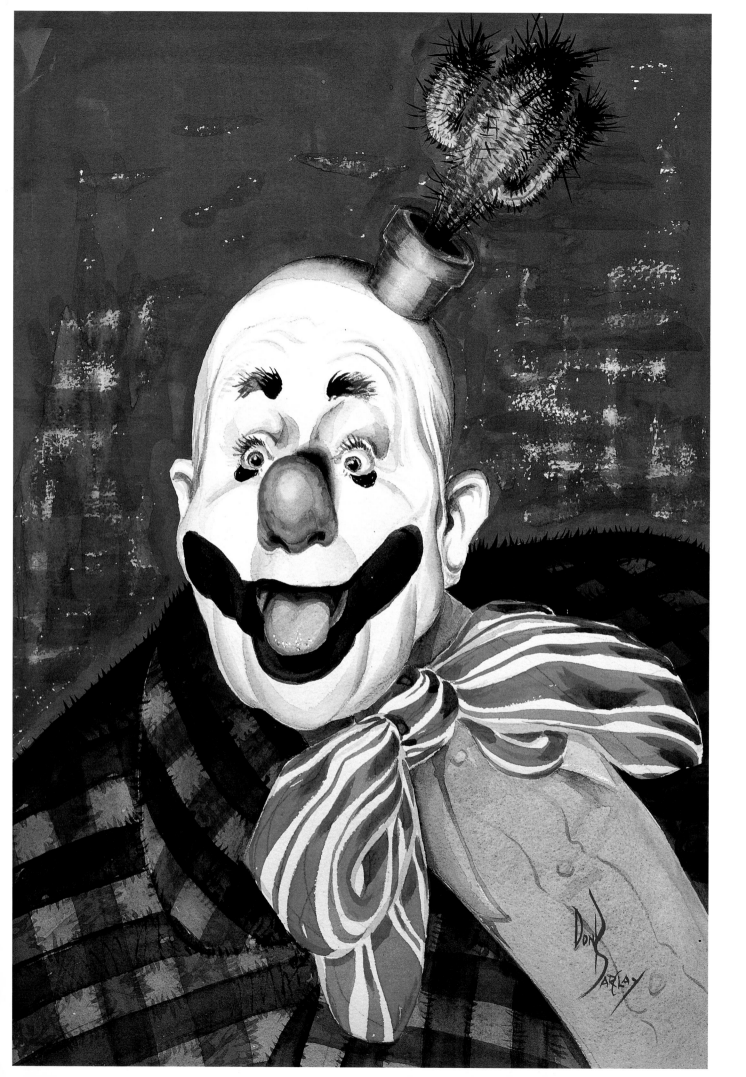

I MET A CLOWN PAINTING
I LIKED

Staring out at us from the surface of a canvas, all Clowns in all Clown Paintings tell a bittersweet story of surprise. No matter how many times life hits them square in the jaw, they bounce back. It's that bounce-back, sweet wonder in the face of an oncoming train, that draws me to them.

Tell a Clown you hate him. He's surprised. He's hurt. Tell him you hate him again. He's surprised. He's hurt. Tell him fifteen, fifty, five hundred and fifty times. He's surprised. He's hurt. A Clown never learns. He doesn't think. He acts. His life experience does not make him wiser, just more surprised and more hurt.

I feel for the plight of the Clown in his never-ending quest to find an audience, any audience. After all, I'm an actress. But never in my wildest dreams did I imagine I would become a Broadway Danny Rose—type trying to procure a better venue than the neighborhood garage sale for Clown Paintings.

It started one morning at the Pasadena Rose Bowl Swap Meet. I was picking my way through a collection of wooden sombrero men bookends when I had an epiphany. I met a Clown Painting I liked. He has a big, red nose, with a big, black mouth slapped across his big, white face. His tongue, hanging out like a dog's in mid-pant, adds a kind of pathos to one hell of an astonished smile. On top of his head, slanting to the right, lives a little cactus in a tiny terra cotta planter. To round everything off, he wears a red-and-white-striped scarf tied at his neck in the prescribed jaunty fashion, highlighting his checkerboard jacket. At the bottom of the canvas, on a crisp, almost glowing, white shirt, hovering between buttons, impossible to miss, is the artist's signature in blue: Don Barclay.

Who is Don Barclay? And who are his compatriots, that legion of other "unknown" painters who have tried to forge a path into the heart of their insane subject matter? Why were they drawn to Clowns? Why did great artists like Edward Hopper, Toulouse-Lautrec, Pablo Picasso, Max Beckmann, and Henri Matisse paint Clowns, too? What is the appeal of Freddie the Freeloader, Ronald McDonald, Clem Kadiddlehopper, Weary Willy, Clarabell, Patches, and Bozo?

In our media-dominated society, where slick images glossed to perfection seduce us with superficial promises, at least the Clown—flinging himself outside the ordinary range of experience or explanation, without questioning the consequences—is unique. Who knows, maybe a Clown image challenges artists who want the mastery of their vision to expose the human experience at its most transcendent on one hand, and on the other, its most tragic. Maybe that's why the myth of the Clown is so compelling to them. Maybe great artists like Edward Hopper, and not-so-great artists like Don Barclay, were moved by the self-effacing heartache plastered on a Clown's face, a face that secretly reminded them of themselves. Maybe, like Clowns who hand out balloons at the opening of the latest used car lot, artists too have humiliated themselves for their art.

But, in the humiliation sweepstakes, it's Don Barclay who takes the prize. His contribution to painting mirrors a Clown's contribution to comedy. What kills me about him is the fact that even though his accomplishments were destined to collect dust in the moldy basements of distant relatives, and in spite of a crippling lack of incentives made worse by dismissive judgments, for Don Barclay, the effort was all.

It's impossible not to imagine Mr. Barclay's teardrops intermingling with his brushstrokes as he stands before his masterpiece, a work completed in the grand tradition of the ugliest genre of them all—Clown Paintings. Yet, no matter how crudely realized, his and his friends' body of work has a quality of surprise, which at best is intuitively stunning, at worst, unsettling. Discarded in the landscape of America's visual wasteland, these rank amateurs' dogged attempts to put a stamp of personal expression on the map link us to them. Beauty draws them. It draws us. It tears at them and us as well. Yet, when most people stop to look at Don Barclay's Clown looking back at them, they walk by without a second glance.

But the Clown won't go away, and neither will Clown Paintings. They continue to be reborn in the backyards and garages of seemingly normal people's imaginations. If the Internet institution eBay is representative of America's buying patterns, then the fact that there is a separate section for Clown Paintings speaks of some primitive yet undying urge, not only to buy Clowns, but to paint them as well.

Comedians don't paint Clowns. I was told Phyllis Diller did, but it turns out she specializes in jugglers only. Red Skelton painted them, but he was a rare exception. Apparently, most comedians don't like Clowns, and they don't want paintings of them in their homes either. The book *Images from the World Between* describes how, when Jerry Lewis purchased his Bel Air mansion in the early '60s, he decorated his living room with a giant painting of himself as a tramp-style Clown,

complete with stick and bandanna. A family portrait featuring his wife, his children, and his pets as a troupe of sad-eyed harlequins in the style of early Picasso hung next to him. Although it didn't surprise me that the King of Comedy would embrace the Clown, why hasn't anyone else in the last forty years?

In an effort to understand the contempt comedians feel toward Clowns and Clown Paintings, I decided to call Woody Allen to see what he thought. It wasn't pretty. I called my friends Steve Martin and Marty Short. They were supportive of my efforts on behalf of the Clown, but I could tell they were not exactly enthusiastic. Then I started calling funny people I didn't know. I called Jay Leno, Joan Rivers, Chevy Chase, and Robin Williams. The list got longer. I called Ben Stiller, Bobcat Goldthwait, Ellen DeGeneres, Carol Burnett, Don Knotts, Dick Van Dyke, and even Jerry Lewis himself. Without exception they were willing to take on the subject, but only a few of them had kind words. This I-would-never-be-a-member-of-a-club-who-would-have-me philosophy did not entice them to linger over such losers. As for Clown Paintings…forget it.

While the people who revealed their thoughts in this book are National Treasures, even though many of them described Clowns as "drenched in sadness" or "cowardly," I have to disagree. To me they are not "horror filled," "pathetic," or "monstrous." Clowns are not the bottom-feeders of entertainment. They were the precursors of our most beloved superstars, our legendary television giants, America's own comic geniuses.

As their collective souls leap out from the boundaries of their wooden frames, I am moved by the Clown Paintings in this book. Their eternal look of sheer astonishment at the uncertainty of life talks to me. I think they're beautiful. I love their bulbous red noses and their hideous hair. I love their outfits. I love their white gloves and their baggy overalls, and even their oversized shoes. I love their "appalling sentimentality." I don't find them terrifying, and I am not embarrassed by their all too public display of loneliness—at least they're not afraid to show it.

If we continue to distance ourselves from them, I believe we will be guilty of denying an essential part of who we are. Maybe it's time to realize how much we have in common with the Clown, certainly in our moments of terror, at 2 a.m. when it's just us stuck in our mysterious bodies questioning our undeniable nothingness.

Maybe it's time to recognize that, like the Clown, we've all gone for the laugh, sold out on occasion, dressed for effect, and paraded our hearts on our sleeves. All of us have begged for attention and cried out in loneliness. Each and every one of us has been surprised and hurt, over, and over, and over, again and again, just like the exhausting, repeated shock that is the life of a Clown.

DIANE KEATON

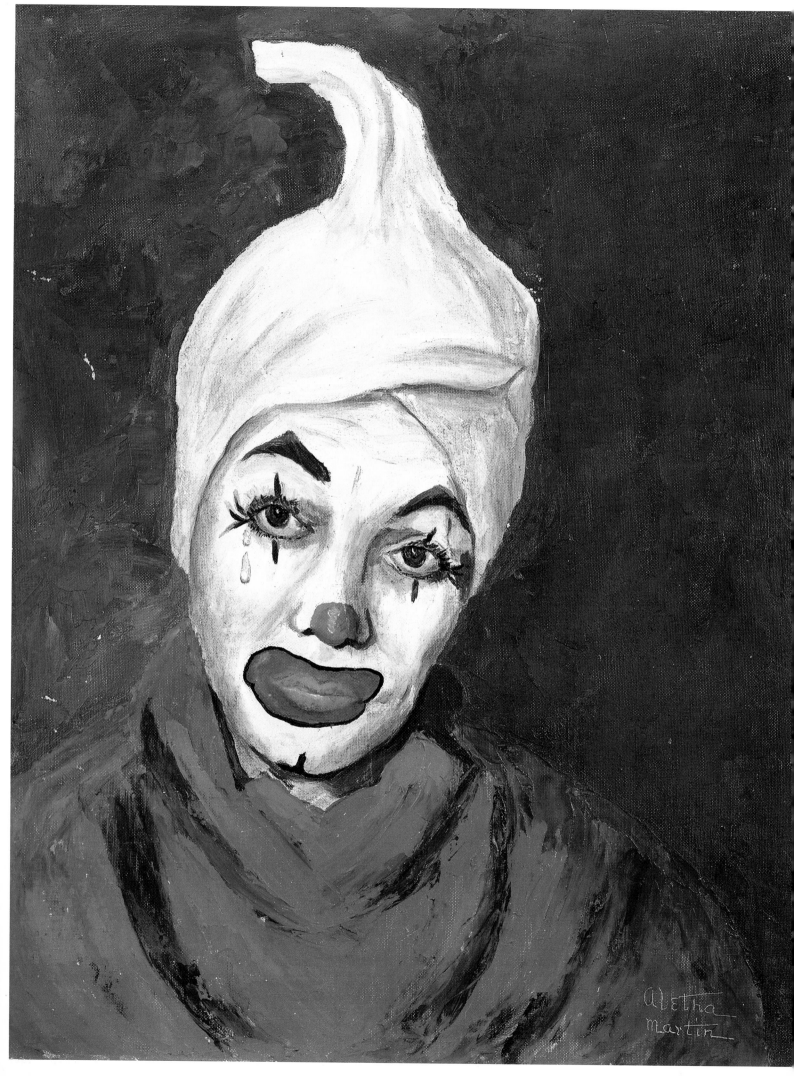

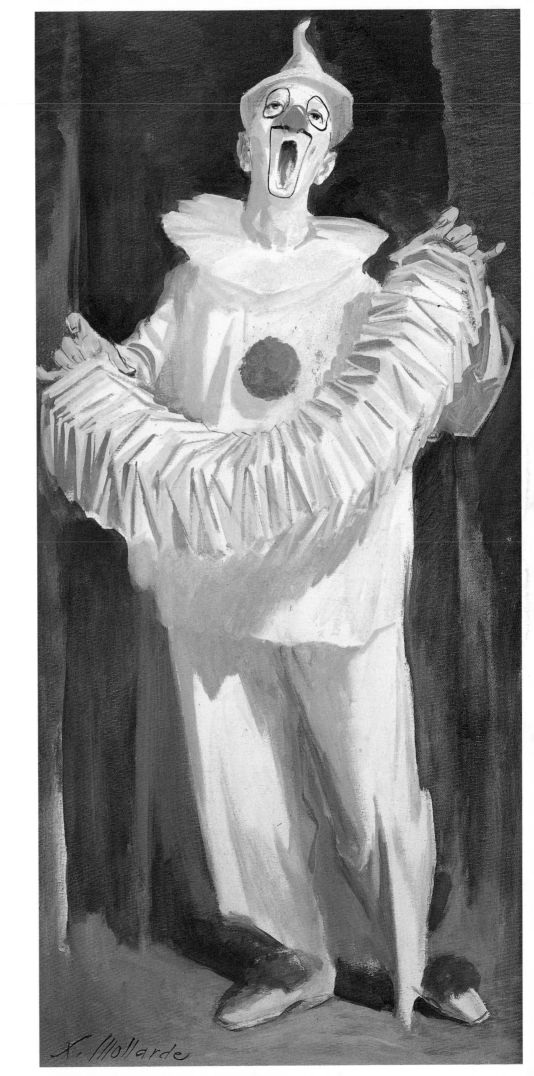

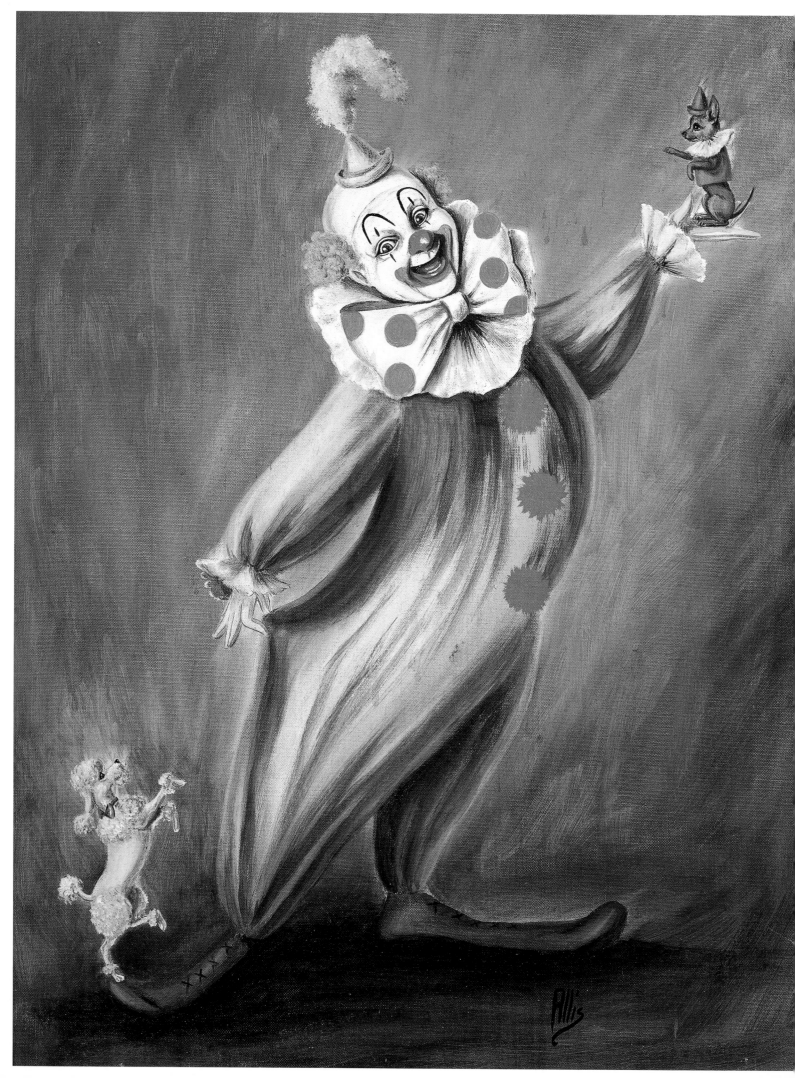

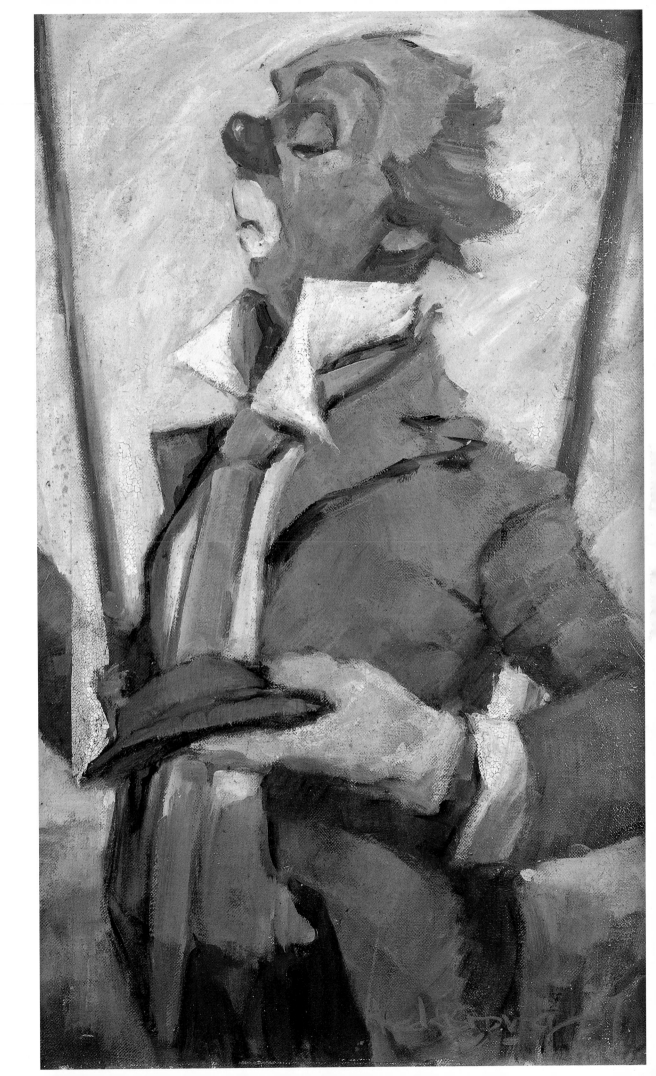

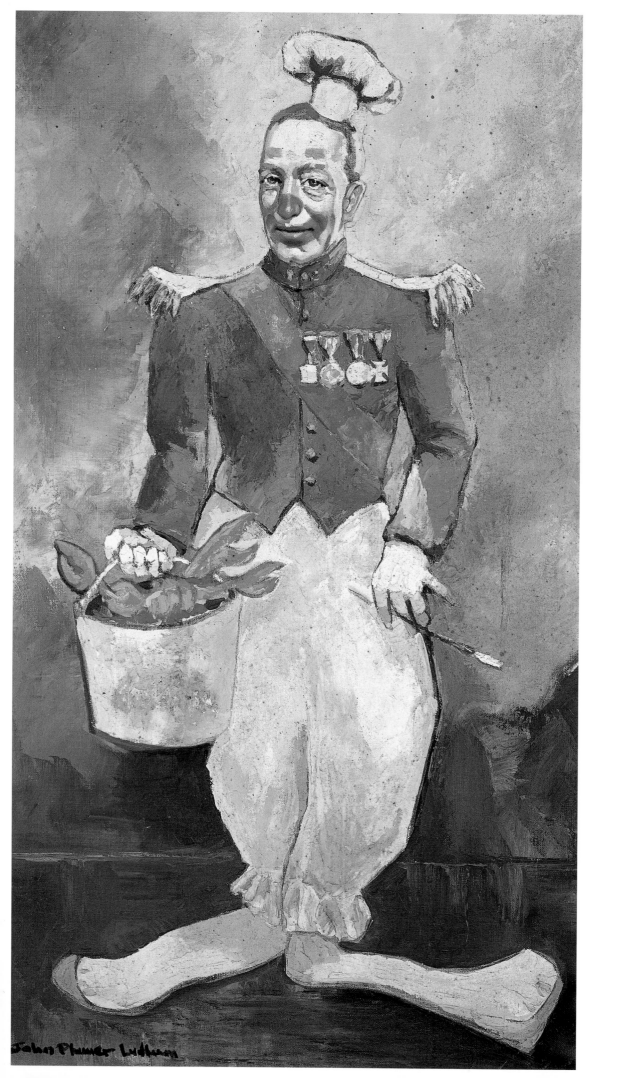

John Plumer Latham

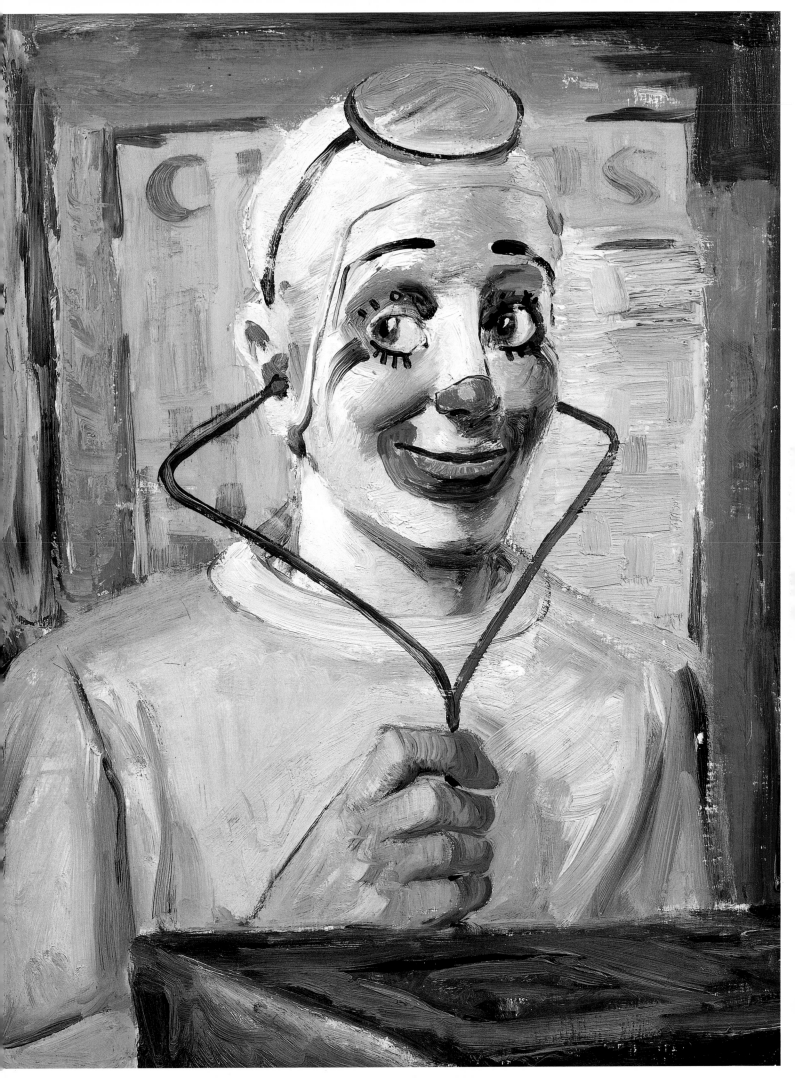

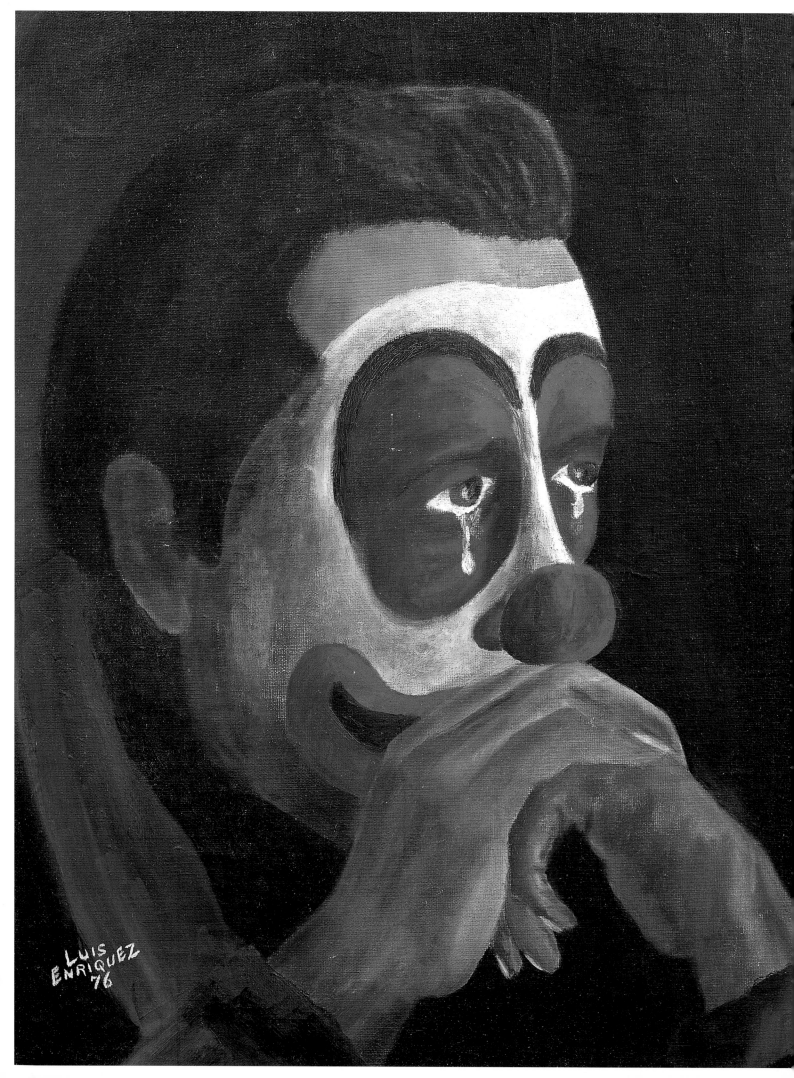

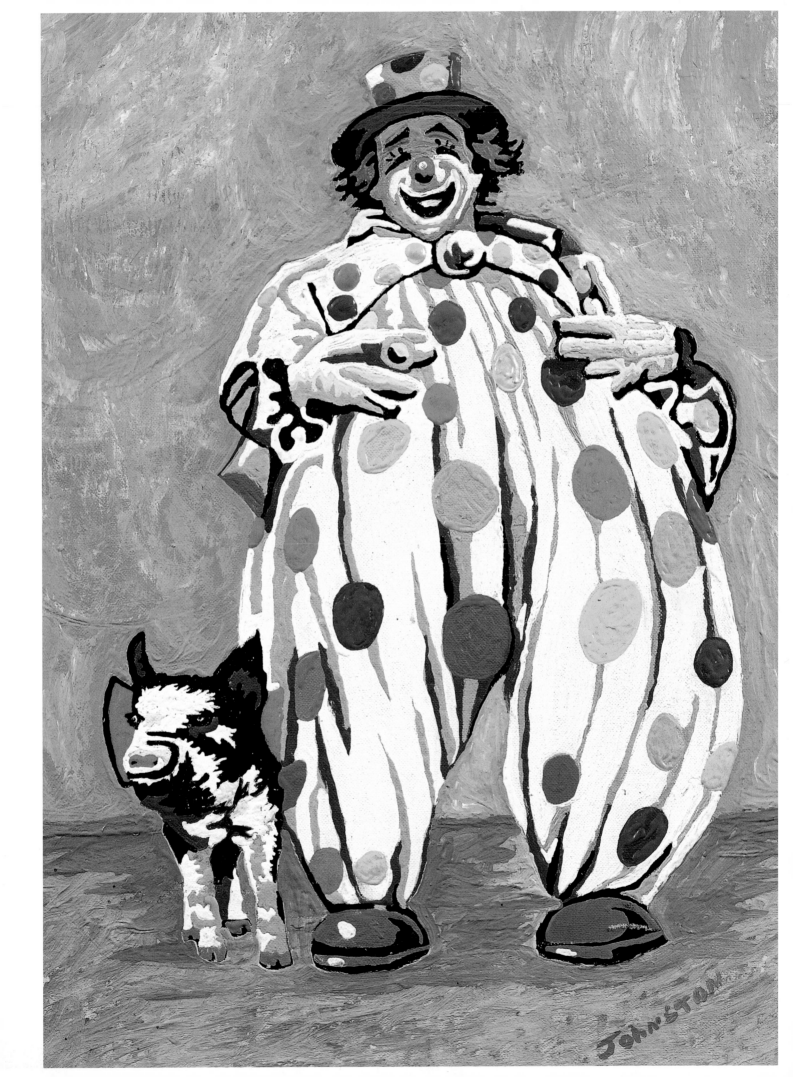

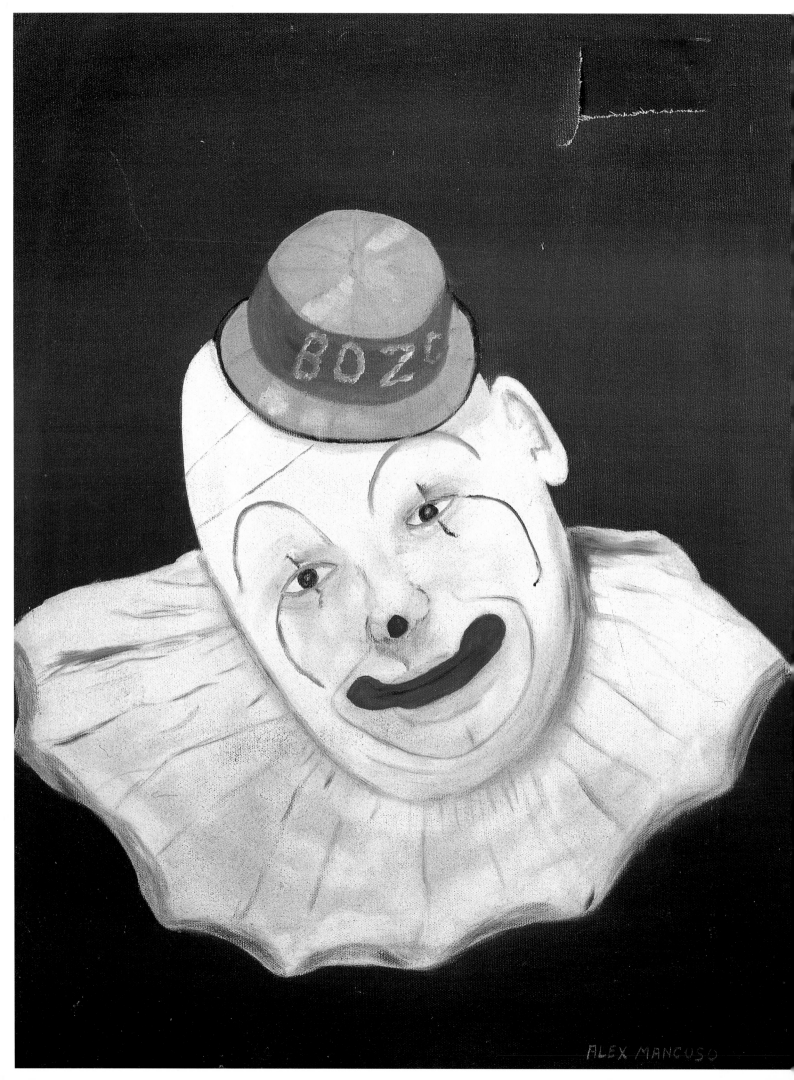

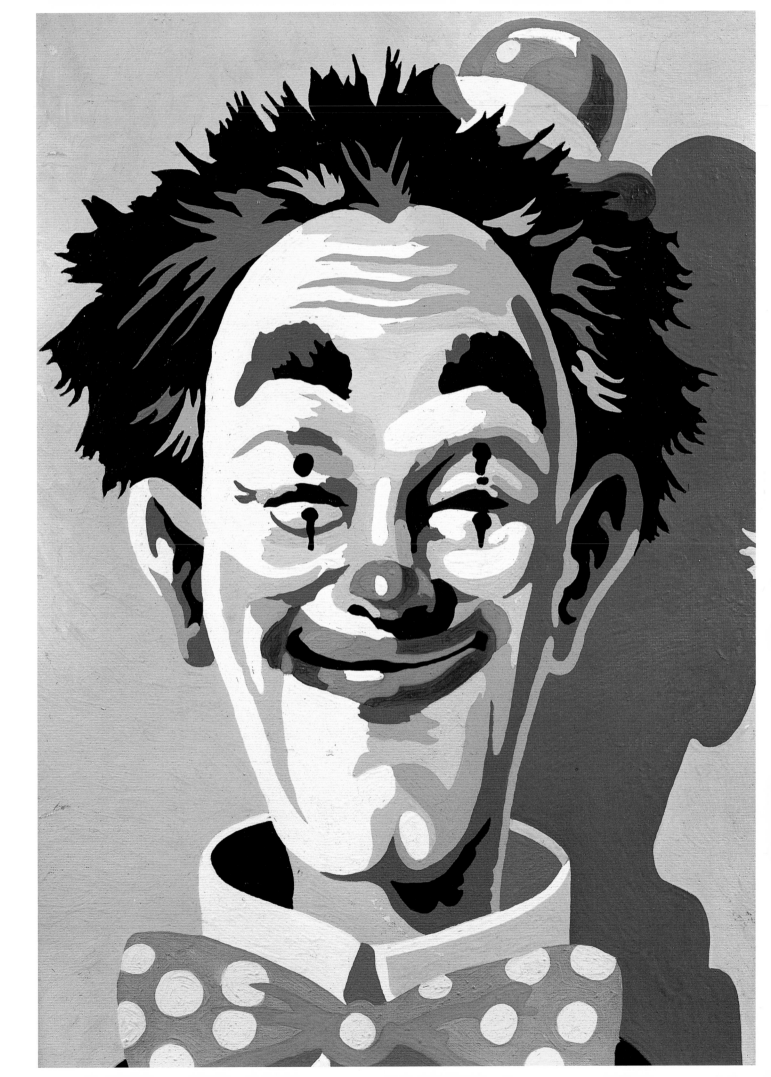

FREAK CLOWNS I HAVE LOVED

For years I've had the oddest relationship with clowns. The clown at the circus, the clown at the party, even the older Lucy, they've all frightened me to varying degrees. Why must they push so hard? Why is there almost a desperate neediness in their desire to get a laugh? Isn't their makeup just a tad thick? Then one night, I experienced an epiphany. While flipping around the tube, I stumbled upon a retrospective of my own television work and was suddenly struck with a newfound appreciation for the subtleties of an Emmett Kelly. Even my face seemed overly clown white. Could clowns have had a greater influence in my life than I had imagined? And what kind of clown did I favor? And why was I now writing in the style of Shirley MacLaine? I had to go back to my own childhood to find the answers, for Oprah once said that's the thing to do.

My first experience with clowndom was not in the circus at all, but on the street where I grew up in Hamilton, Ontario, Canada. Strange as it may seem, we actually had a circus clown who lived seven doors down. His name was Happy Hugo and he was one of the most depressed people I'd ever met. Granted, working as comic relief at the local Dodge dealership can wear you down, but my, he could be moody. I always assumed he and his wife, Olive, had met in the circus, because around five o'clock, she always looked like she needed a shave.

Happy Hugo hated all the kids on the street and would yell at us to stay off his lawn or feel the wrath of his seltzer bottle. He promised that if we stayed clear of his blessed grassland for a full year, he'd treat us all to the Canadian National Exhibition in Toronto to see the "Clowns in the Freak Show." He claimed he had connections. The power of pull. Of course, we obeyed.

Like any red-blooded Canadian boy, I was nuts for the Clown Freaks. The more grotesque the better. There was Schlitzy, the pea-headed clown, with his little pea-head and his Clarabell hair sticking out the sides. No Middle Myrtle was another personal favorite. Beyond having floppy shoes, her measurements were 37-0-36. Now, one might assume those measurements would be a turnoff for romance, but they certainly weren't to her lover of fifteen years, fellow Clown Freak, Spike Boy.

The Spike Machine, as his friends called him, was a temperamental fifty-six-year-old Armenian who didn't hesitate to reprimand his audience if they dared to make a peep. "Please, can I have a little respect for my craft? Good God in heaven, this isn't easy." He would then shove a two-foot spike up his nose. I was in rapture. It was like seeing Sinatra without being burdened by the music.

Bones, the Defensive Fat Clown, would yell at the audience, "What the hell are you looking at?" Of course, the real freaks were most of the people in the tent watching the Freak Clowns. However, we can discuss that in another book entitled *Foods I Have Quickly Devoured.*

As the day ended, as all days must, we piled out of Happy Hugo's very tiny little car and fanned out toward our respective homes. But before I did, Happy Hugo specifically reminded me, through an alcoholic slur, that if I ever wanted to see No Middle Myrtle and the gang again, I'd best stay off his lawn for yet another year.

He didn't have to worry. Happy Hugo was not my cup of tea, but the Freak Clowns were a different story. I would later appreciate the extent of their influence.

Not a blade on his grass would be touched.

MARTIN SHORT

HEY CLOWN!
THE LIGHT IS GREEN

I enjoy the use of *clown* in the American vernacular when the word is applied with a derogatory and hostile delivery—as in "Hey clown! The light is green!" Or "Jesus! Look at the clown in that ultra-light near the power lines!" In the second high school I attended, the principal, a combat priest, told my father, "Mr. Aykroyd, your son is a clown! Isn't there a school in Moscow for clowns?" Since then I've only been to St. Petersburg.

DAN AYKROYD

COMPENDIUM OF CREEPY

All I have is a lot of questions: How much do I have to pay to not have one of these paintings hanging in my house? If they're so funny, why are they always drenched in sadness? If they're so *funny,* why are they so frightening? Why are clowns a compendium of creepy? And what does it say about us that they make us howl with laughter? Is it a form of what Germans call *Schadenfreude?*

Why don't I get these guys? And why are they almost all guys (but *androgynous*)? I *should* get them; I am pre-programmed in this stuff. My father came out of vaudeville (after medical school); he was a ventriloquist (on *radio*), which is certainly high on a list of eccentric performers' professions. He would, on occasion, get into full clown costume. I grew up around Red Skelton. On Halloween, a clown was my disguise of choice.

Why, in later years, was it only when I was allowed to do comedy that I could escape the self-consciousness I always felt acting? Why did making a fool of myself in front of an audience bring me inexpressible joy? I am comfortable with comedy. I love to laugh. Why (and I am not alone here) do I hate clowns? And why does Diane collect paintings of them (which she will eventually sell for millions of dollars and then I'll be sorry)? Why?

CANDICE BERGEN

SAVE ME!

There are two, no, three kinds of clowns.

The least talented and most reprehensible is the "class clown." The audience is small; no pay; plenty of payback—from frustrated teachers and administrators. However, if you're good enough and can actually get a teacher to laugh, as I was able to do, you can get good grades for your performance. Most of my class clowning was physical—arriving late to class, surreptitiously spilling papers, knocking over a waste-can, making a huge racket—all the while appearing apologetic for the "unfortunate disturbance." I got away with a lot.

Which brings me to the second kind of clown. Of course, great physical comedy comes from great clowns. The greatest—Chaplin, Keaton, Jacques Tati—have no need to paint their faces or dress up like circus clowns. To the extent that they appear normal, like an Everyman, and behave appropriately by typical societal standards, they beget belly laughs very successfully.

Finally, I can think of nothing more horrifying to a child than having the third kind of clown, the circus-type, appear at his or her birthday party. What could be more confusing than the bellicose, aggressive behavior of some half-man, half-beast painted up to the hairline and gesturing in sudden, frightening fits of neediness? His very unpredictability is highlighted, accentuated by the disparity between that huge, painted grimace covering the lower half of his face, and the small, inexpressive mouth lost in the grease—but not lost on the confused child who at a glance duly notes this inhumanity. "Who is this guy? What does he want? What's he going to do to me? Is he really happy or is he angry and unbalanced? Where's my mom? Where are the real people? Save me!"

I hate clowns.

CHEVY CHASE

AH HA, AT LAST I'M ONE OF THEM

Looking at pictures of clowns reminds me of when, as a kid, I walked with my friends five miles along the railroad tracks to get to the grounds on the outside of town where the circus pitched its tents. Each summer brought us the lion tamer's act that scared us half to death. The trapeze artists always thrilled us. But I especially loved the clowns who made us laugh, with their pratfalls or free-for-alls, or when fifteen of them got out of a tiny car, one by one by one.

I don't know that I ever consciously thought I could become a clown, but about thirty years later, Bill Cosby and I were doing a sketch on television where we filled a bucket with water. After we surreptitiously switched buckets, we hurled the contents at the audience, and instead of water soaking them, confetti fluttered out. It was the same trick I had seen the clowns do a dozen times. I remember thinking at the time, "Ah ha, at last I'm one of them."

DON KNOTTS

CLOWNS WEAR BRIGHT CLOTHING.
I DON'T

When I heard the list of people who were asked to write for this book, there was a common theme—funny people. We funny people are in some way linked to clowns. I'm not sure how I feel about that. I don't think of myself as a clown. Clowns wear bright clothing. I don't. Only for a brief time in the 1980s did I indulge in a jumpsuit, and now I regret it.

Clowns paint frowns on their faces and never say anything. They've never made me laugh or even feel slightly happy. They don't seem to be liked by anyone. Even bulls go after them at rodeos. Why do they continue? What purpose do they serve?

And yet I can't imagine life without them.

ELLEN DEGENERES

THEY WERE MEAN

We were at the circus, my first one. I remember the big top and the sawdust on the floor. There were the three rings. The lion, the man with the whip, and a lady in sparkly shorts all were in the middle one. They were the stars. The lady had holes in her stockings, and the man's belly hung out over his tight pants.

I was disappointed as hell. Even the cotton candy was fake. It went away in your mouth as soon as you tried to bite it. I wanted to go home. The circus was supposed to be exciting and scary.

They finished their acts and the lights went out and some horns went "TA-DA."

Then the clowns came on.

They wore wild outfits, and they were all in Technicolor—purple and orange and yellow and red and green and blue. Their painted-on grins were a mile wide, and they were all teeth and flashing crossed eyes.

They were mean.

They slapped each other, and it hurt. They squirted fire hoses and slammed each other in the face with pies and hit each other over the head with rolling pins...hard...and everybody was screaming with laughter.

Then one of them came toward me with a gun in his hands and aimed it right at my face. I screamed. He shot me, and a parasol came out. People were falling down laughing.

I wanted to kill him.

He scared me to death, and I hated him.

I hated all of them.

They weren't funny. They were scary. There was something wrong with them, and I was the only kid in the world who was on to them.

CAROL BURNETT

SOME PEOPLE'S TRASH IS OTHER PEOPLE'S
TREASURE

Some people might think that collecting clown paintings is weird, but I'm not one of them. I completely understand what it's like to build a collection of things others might throw away. In fact, I would advise any new collector to make a conscious effort to collect things that other people don't want, because it cuts down on unwanted competition and high price tags at flea markets, garage sales, and eBay auctions. I should know because I come from a family that spends its free time "collecting."

For years I have collected framed or mounted thermometers with city, state, and country logos on them. I don't know exactly why, but perhaps it's because I spent a lot of time as a child sick in bed with a thermometer stuck in my mouth, and this is my revenge. I have more than one hundred new and old thermometers in my collection. *Franklin Mint* magazine said I was the foremost thermometer collector, until they found a guy in Pennsylvania who had over three hundred.

My family also participates in "collecting" rituals. Aside from the standard aluminum foil, wooden toothpick holders, and Queen memorabilia that my wife collects, we hoard the following. My daughter Kathleen collects individual silver napkin rings with strangers' initials on them. My other daughter Lori's home has fascinating shelves full of "dachshund art," from paintings to ceramic renditions of the little dachshunds on parade. And my son, Scott, and his wife, Elissa, buy new and vintage Hello Kitty and Dear Daniel paraphernalia. A prized possession in their collection is a Hello Kitty waffle iron. My grandmother, who rarely ventured out of the Bronx, collected toilet paper from around the world, and Grandpa Willie was more classic and masculine, collecting "date nails" used in utility poles and railroads that had a date of manufacture on the head. Director and sister, Penny, has the foremost collection of "wounded animal figurines" with painted bandages all over them. When asked by various stars who visit her home why a shelf full of animals

on the mend would interest her, she replies, "It brings me joy because each day I feel they're getting better....I'm not." On the other hand, my father and mother mostly collected nasty things to say about each other.

Thus, even though I understand having collections, clown paintings are not something that ever caught my fancy, or that of many others throughout history. Yes, I know many legitimate artists have painted clowns—Henri Toulouse-Lautrec (in between prostitutes), Edgar Degas (between ballerinas), and Pablo Picasso (painted an occasional clown with a square face)—but none repetitively filled frames with harlequin art. The first clown painting was possibly by an artist who wanted to try out "all of his colors."

There seems to be no record of clown paintings on the walls of cavemen dwellings or in the hieroglyphics of the Egyptians. One might say the reason for a lack of early historical clown paintings was because the first clowns were court jesters who were usually deformed and the royals made fun of them. Painting deformed people was not as popular as fruit and cherubs in those days. Although cute dwarfs quite often made it to canvas, they were mostly in the background of a Goya or a Velasquez. When the deformity rate dropped in the seventeenth century, the jesters went from "physical" deformity to "mental" deformity, spouting wit, puns, jingles, and sarcasm. Aside from a few circus clowns, today's jesters, clowns, and comedians make a living with deformed comic minds rather than bodies. But they still can be colorfully painted in whiteface, festive colors, and phallic limp hats, if one desires.

Enough history. Let's get to the point. Although I'm not a big fan of clown paintings, I do, however, defend and advocate the hobby of collecting them. Some people's trash is clearly other people's treasure. What's terrific is that each person's collection is his or her own, and there are no rules to collecting. Anybody can do it. All you need is the passion to pursue. Go, clown-painting people, rule the world, but count me out.

GARRY MARSHALL

EERIE VIBE

Bozo is the first clown I remember. His fiery red hair jutting out the sides of his bald head; his thick, red lip outline; his black, arched, greasepaint eyebrows. I am not sure if Bozo had his own show, but as a kid I saw him on TV. He wore a light blue jumper, and he ran into the audience while making balloon animals, and gave presents to the kids in the audience. I liked anything associated with presents. Bozo talked, which, I later learned, broke one of the big clown rules. All the clowns I experienced after Bozo, like the ones at the Barnum & Bailey Circus, seemed to be mute and uninteresting.

In fact, I have never really enjoyed the "classic clown" routine. It never made me laugh as a kid. When I went to the circus, I loved the trapeze act, because it was dangerous as hell. I loved the part where they turned off the lights in Madison Square Garden, and all of us kids would whip out the little flashlights we'd bought at the concession stand and spin them in circles, turning the arena into a giant electric pinwheel generated by the crazed and focused energy of thousands of kids deliriously happy to be there. But when the clowns came on, they were hokey. The old bucket-of-confetti routine didn't work for me. Nor did the sweet-male-and-female-clowns-finding-romance bit. It all felt like filler to me, till the death-defying stuff came back.

I feel bad for circus clowns, because it seems they have so much pressure on them to be funny all the time, which is to me the worst thing you can demand of someone. When someone says "be funny" to me, I immediately want to hide, or punch that person in the mouth. Being a clown, I think, is not easy.

But I think my negative disposition toward "real" clowns probably informs my enjoyment of clown paintings. I really like them, even though clown paintings, like clown dolls, can freak you out. At first look, it is the irony that gets you. Almost all these paintings have, at best, either a sad or lost feeling to them. The rest have a somewhat creepy, eerie vibe. And of the creepier paintings, I think my favorite is the one of the clown with red pom-pommed cap, sitting Thinker-like upon what looks like a trunk. Ghostly images of himself loom over his head. His expression looks perturbed, or at least pensive. And even the painted-on smile doesn't make him look anywhere near happy. If I were to title the picture, I might call it *Troubled Clown Pondering the Day's Work Ahead*. I guess I kind of feel for him. The pressure to be funny. It can really get to you.

BEN STILLER

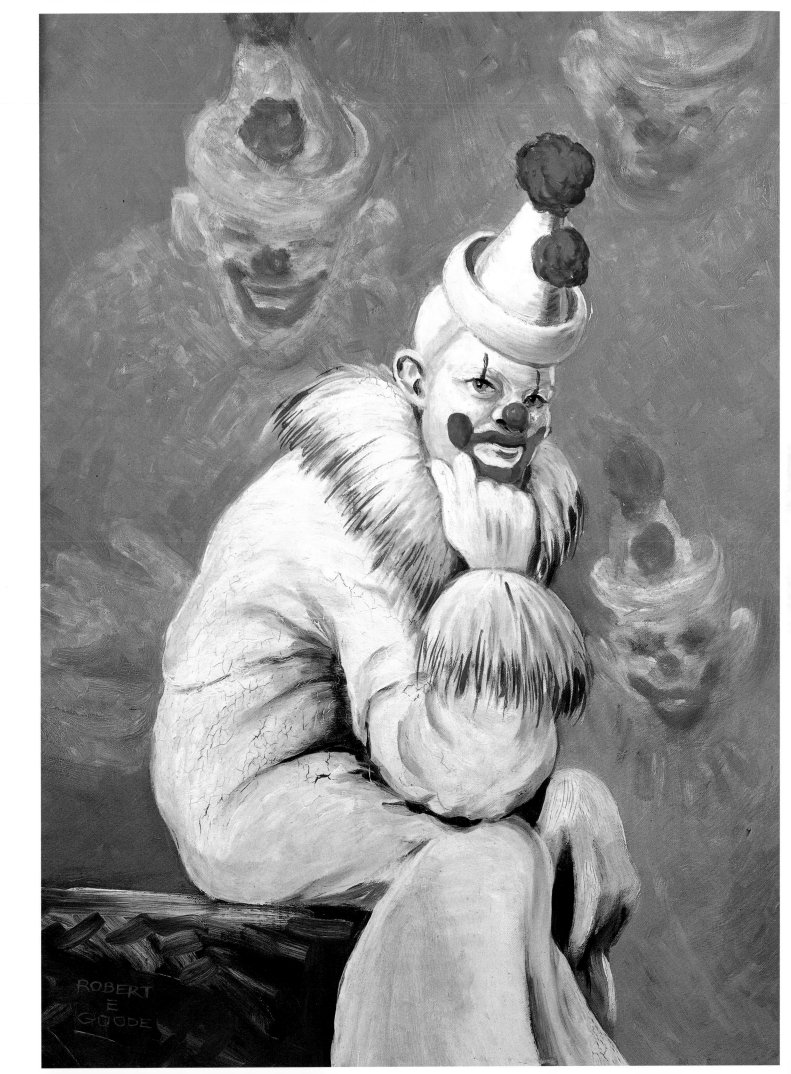

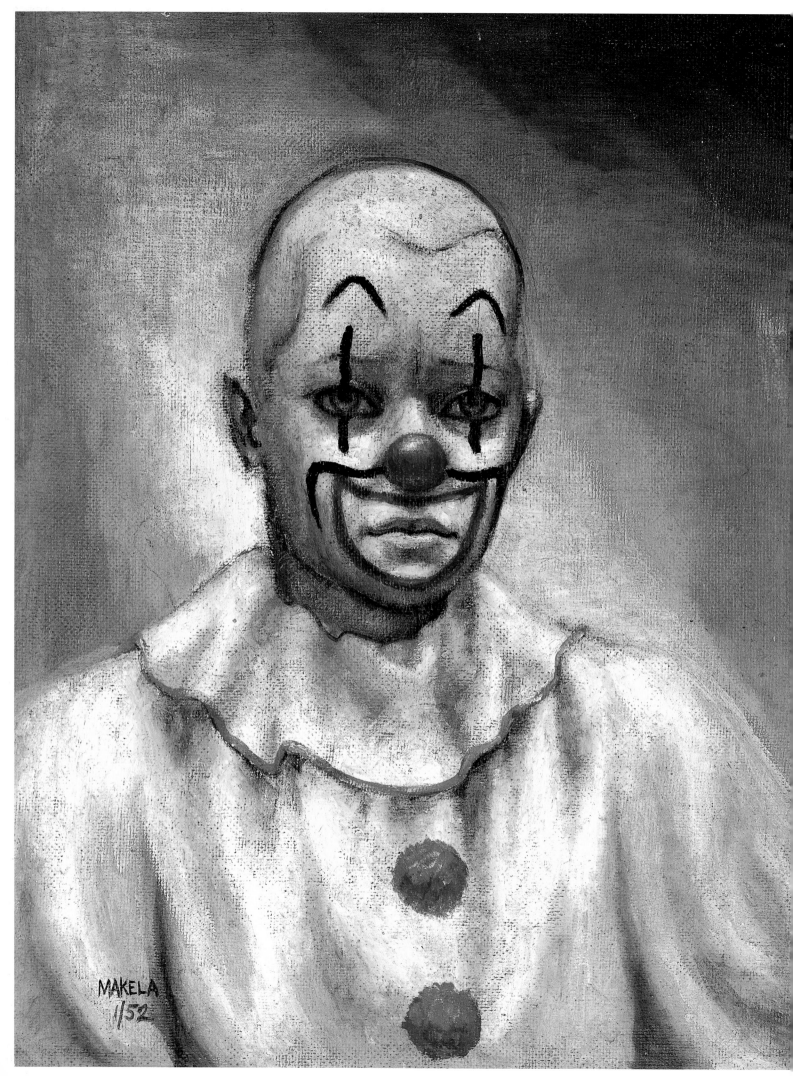

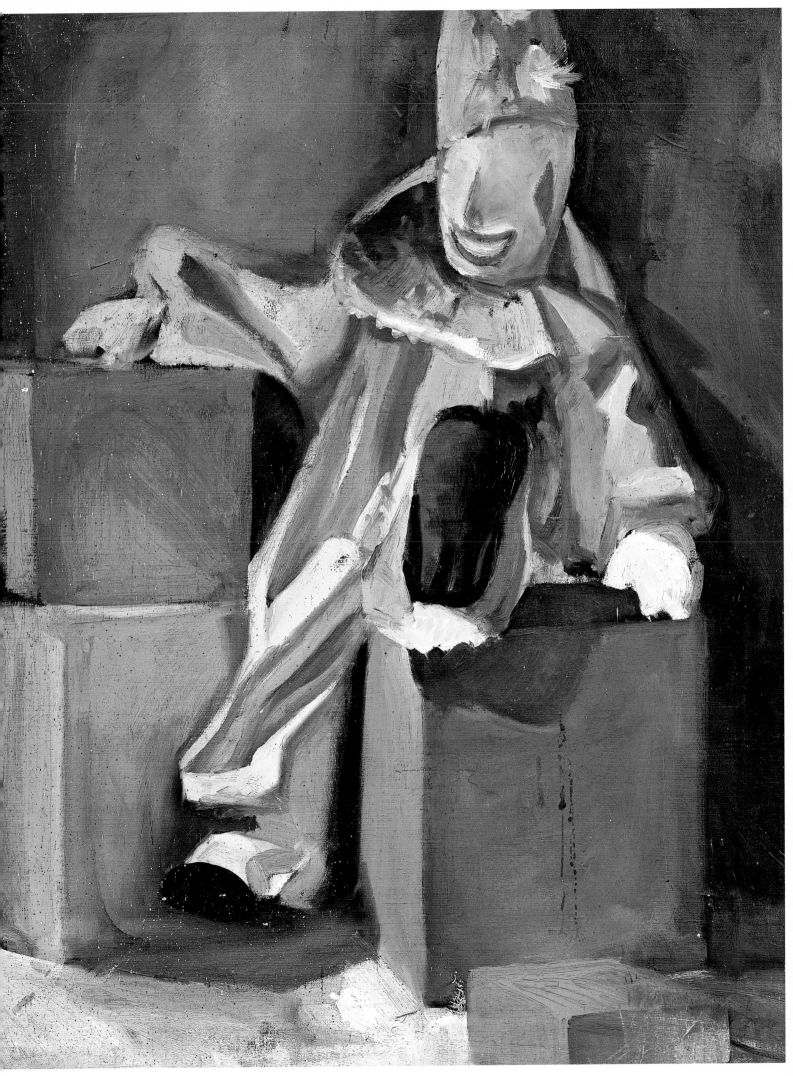

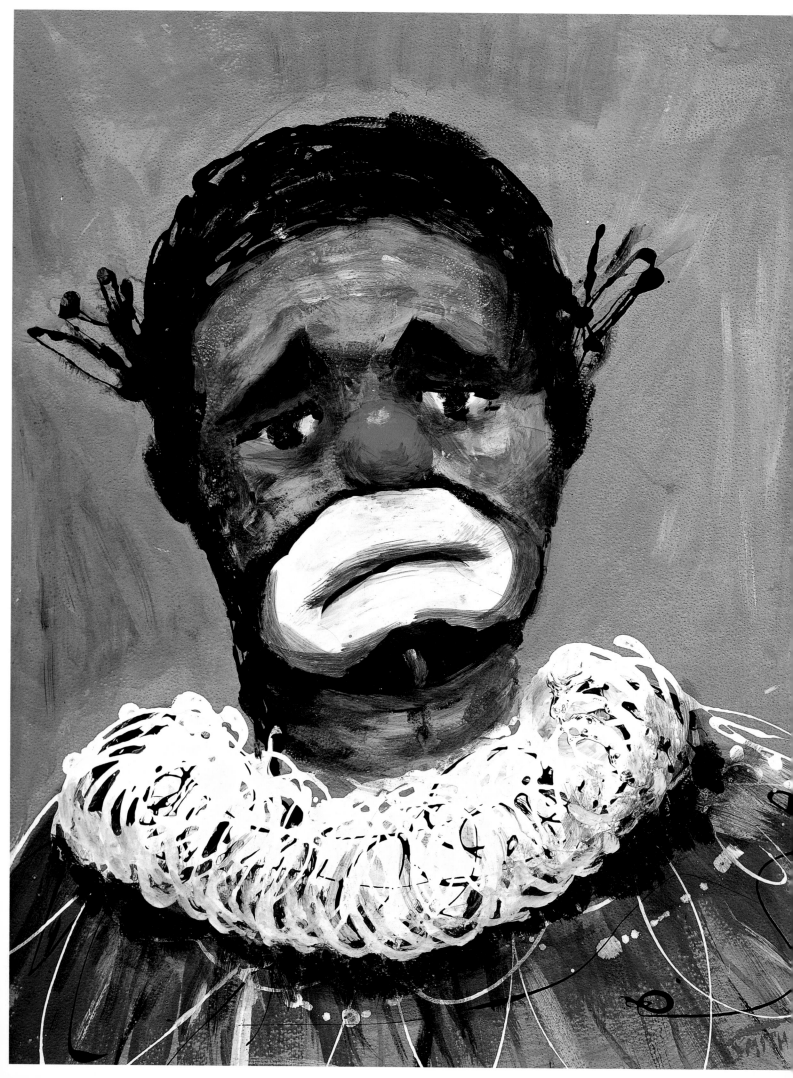

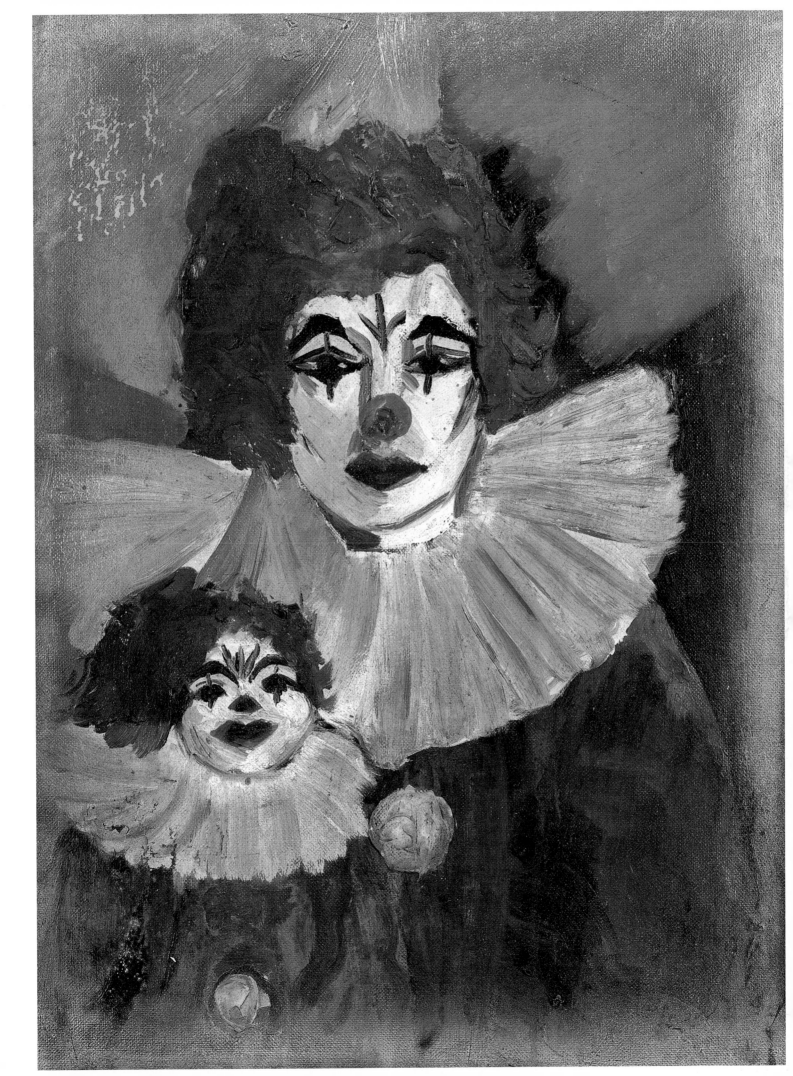

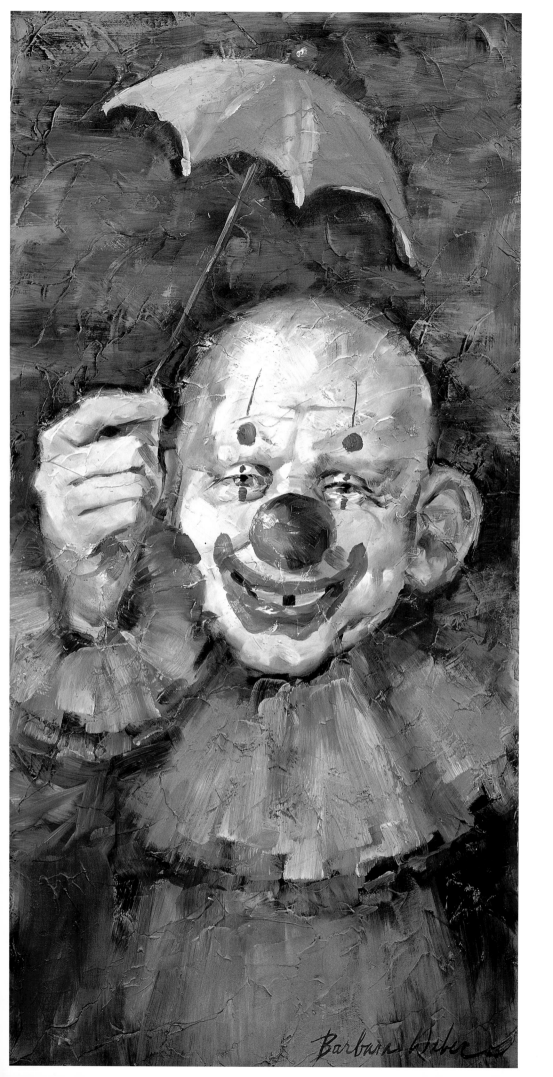

Barbara Weber

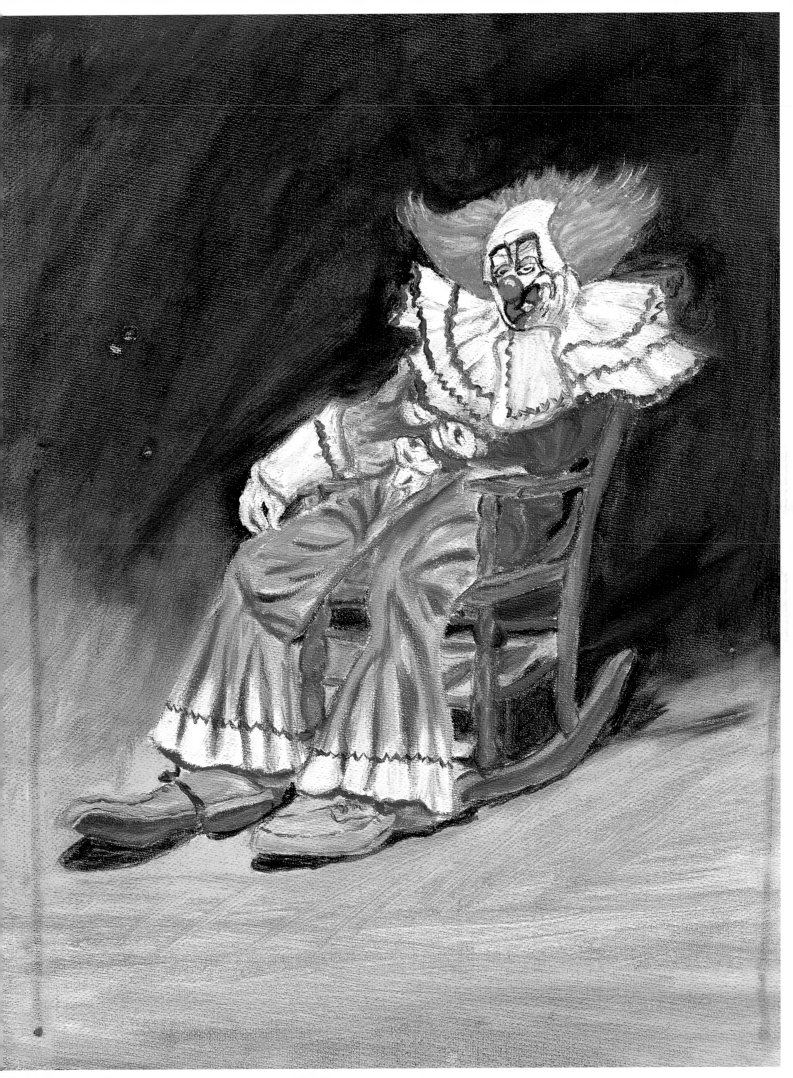

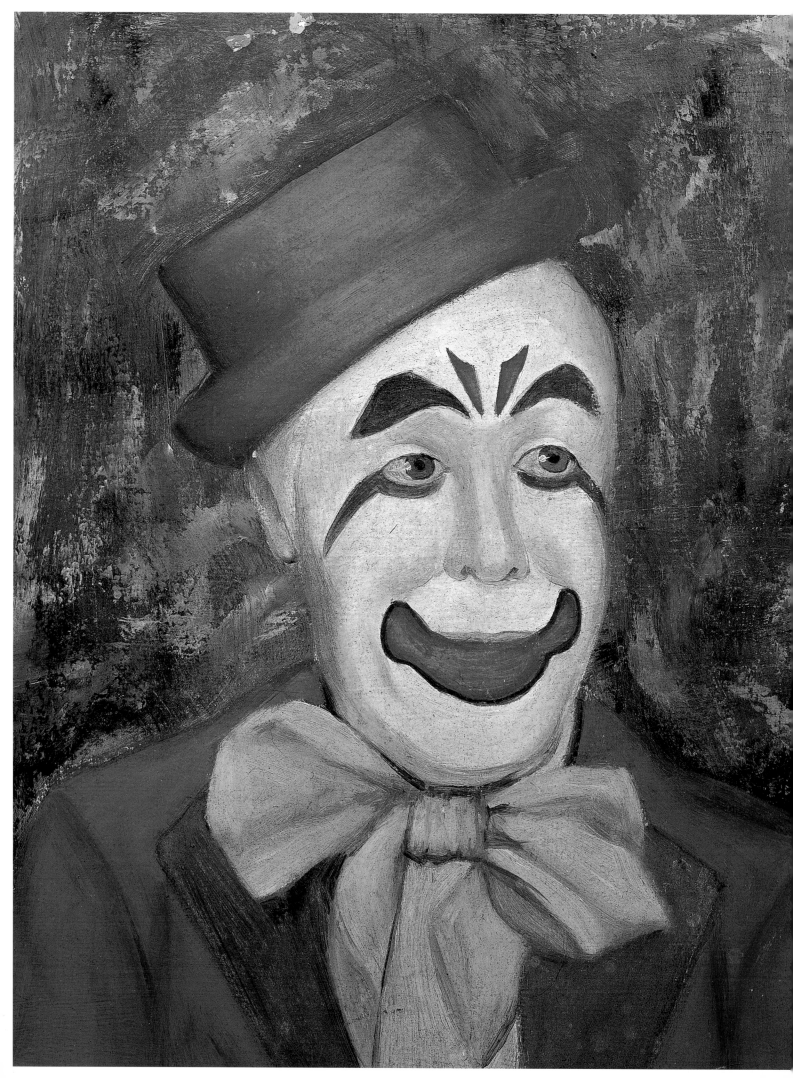

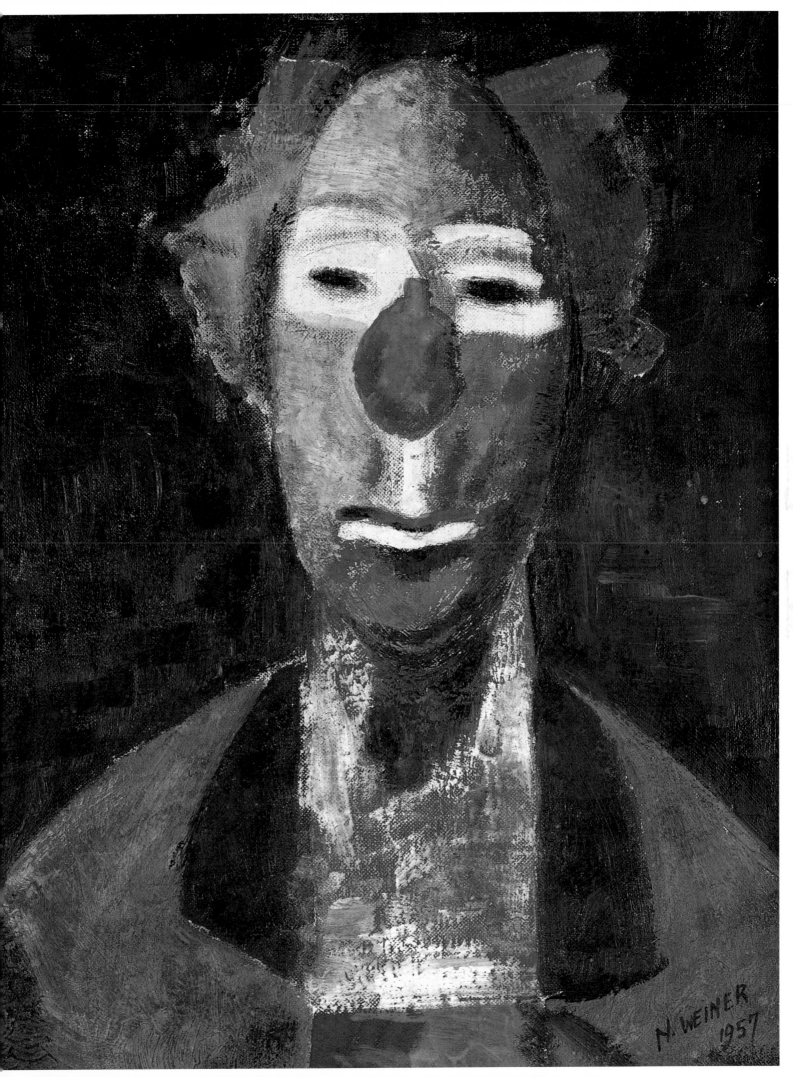

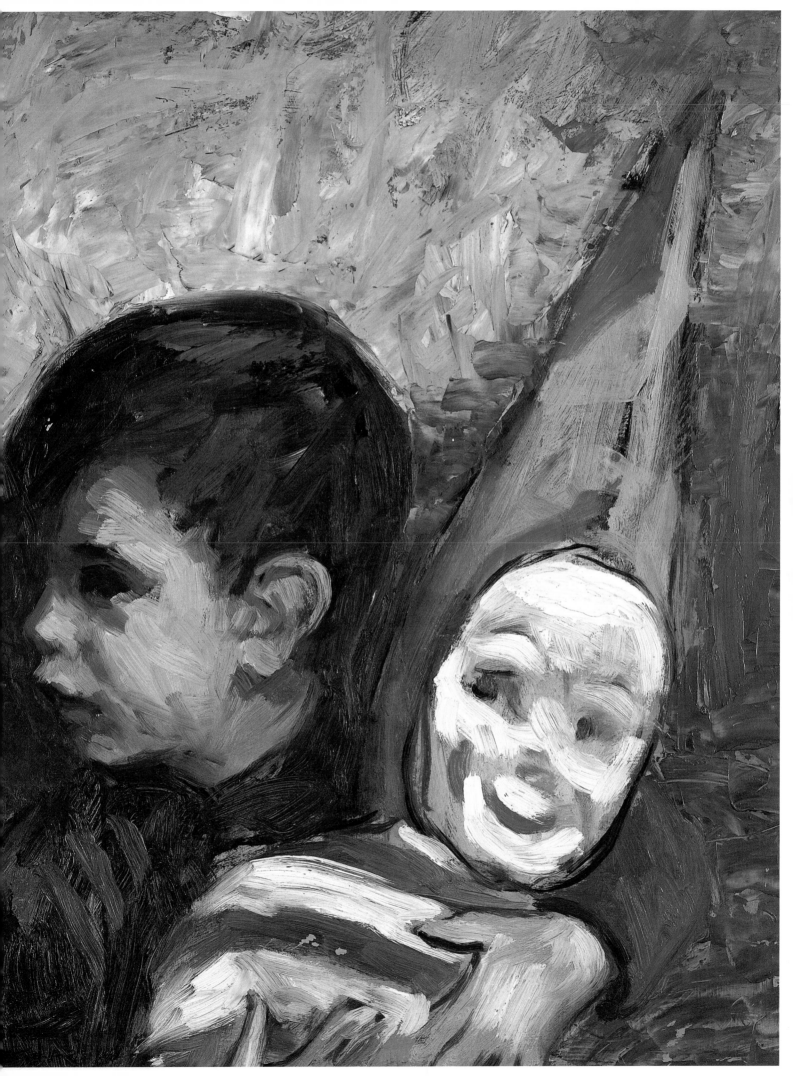

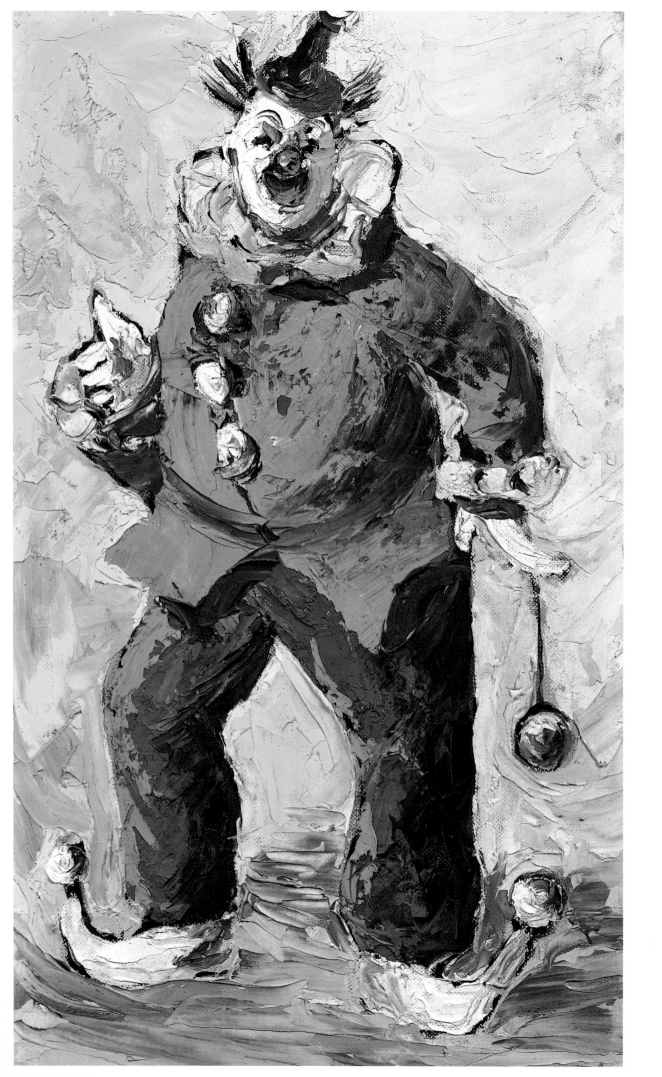

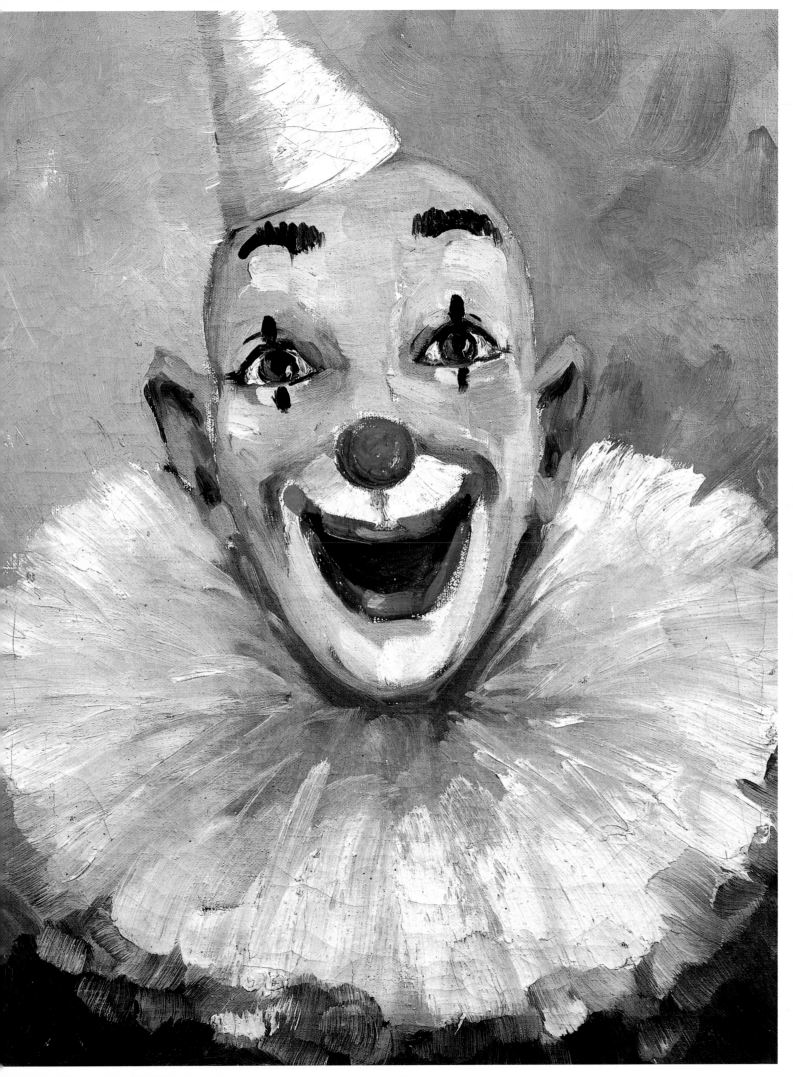

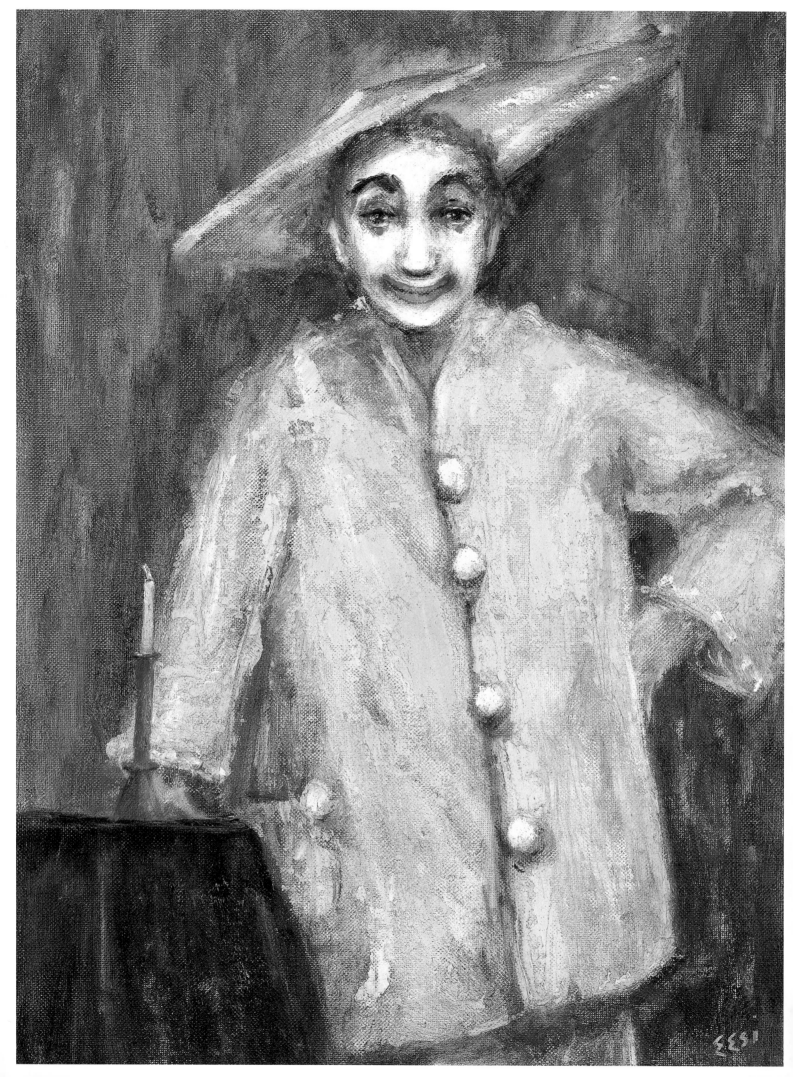

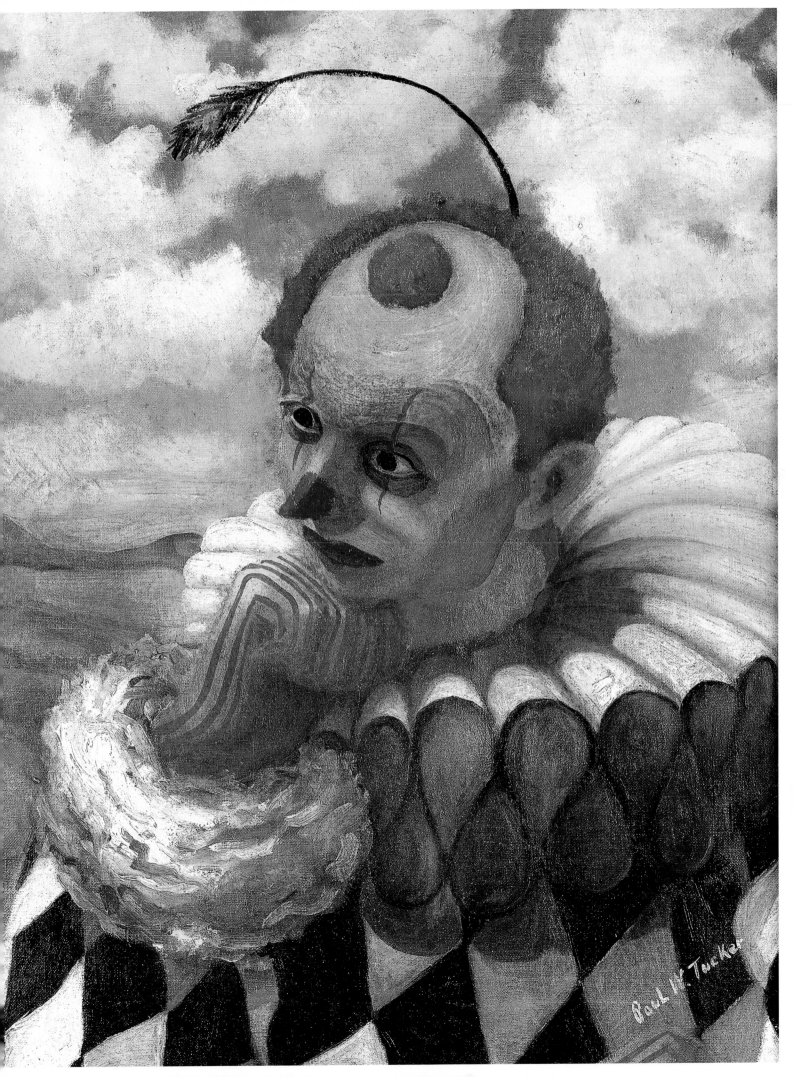

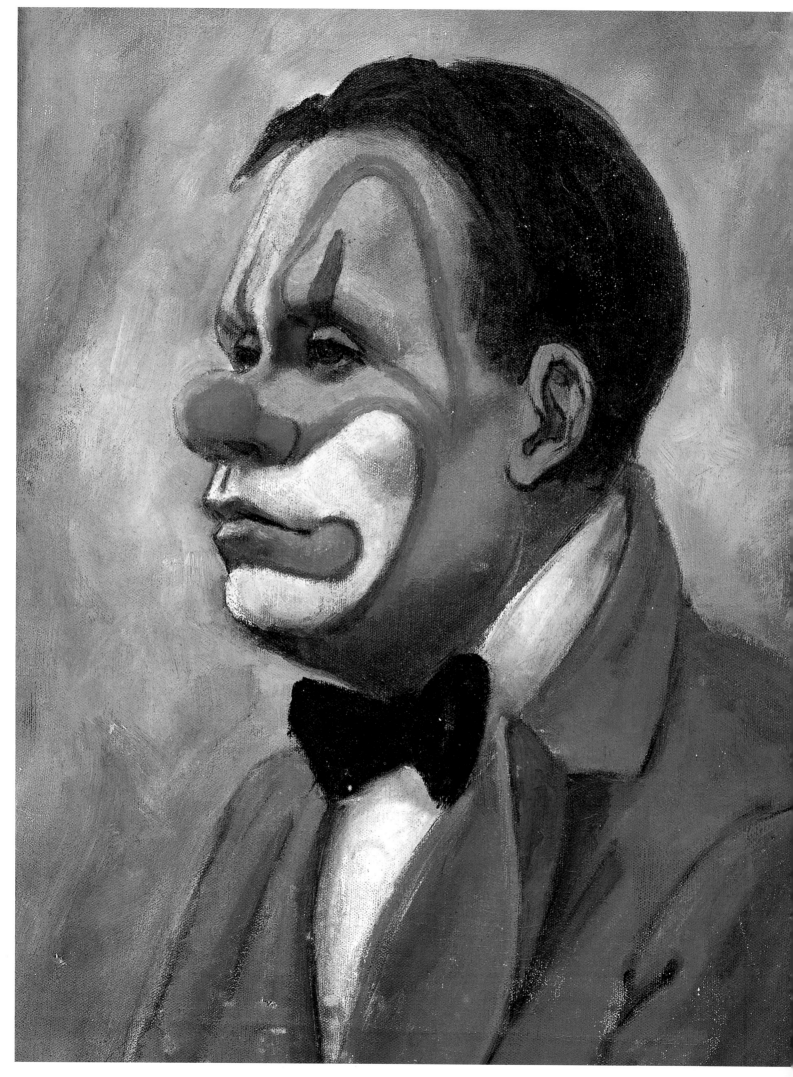

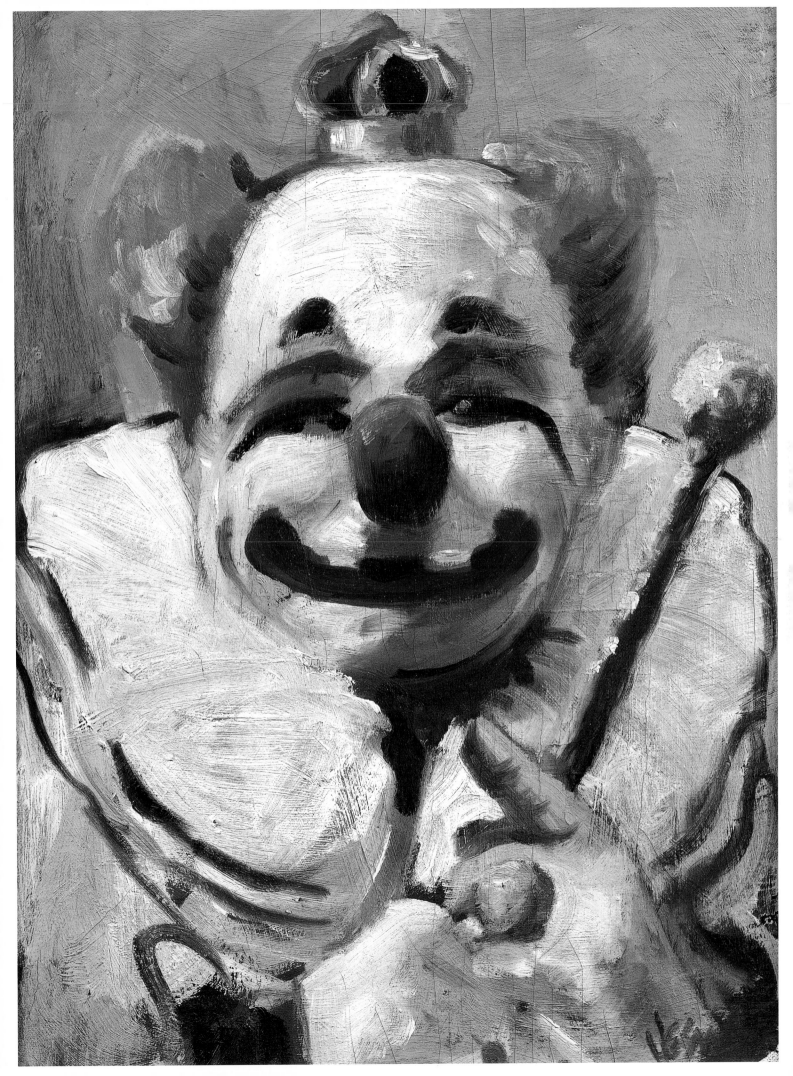

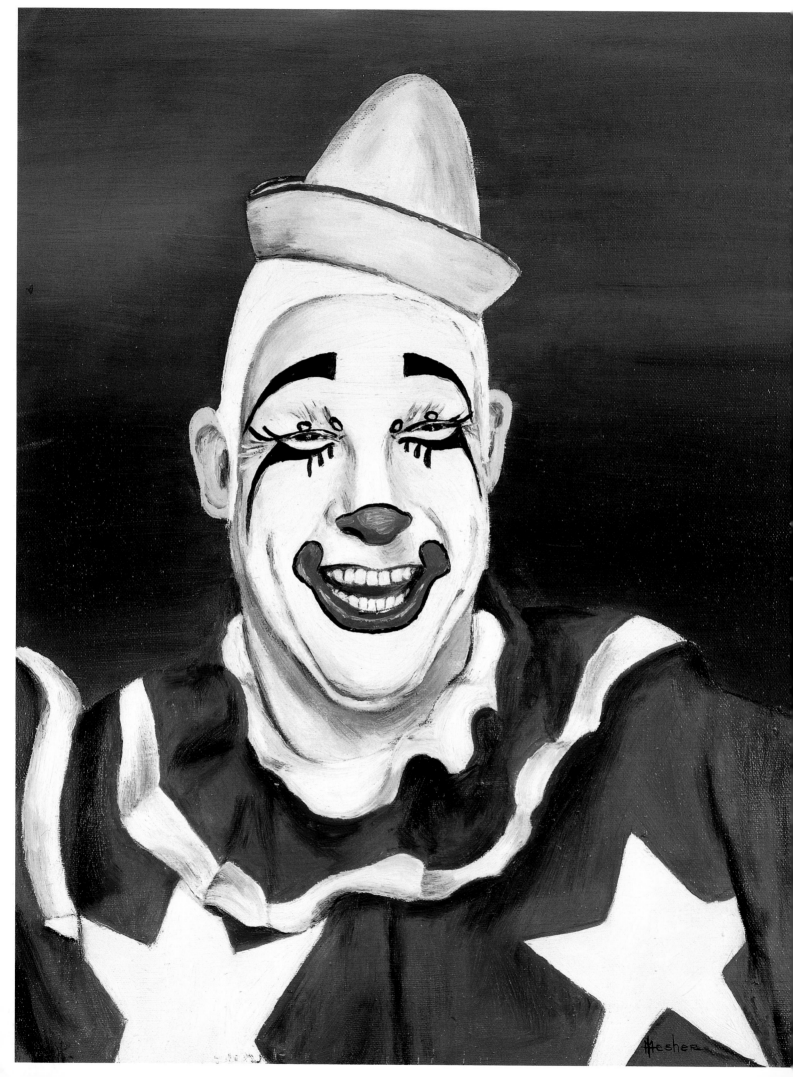

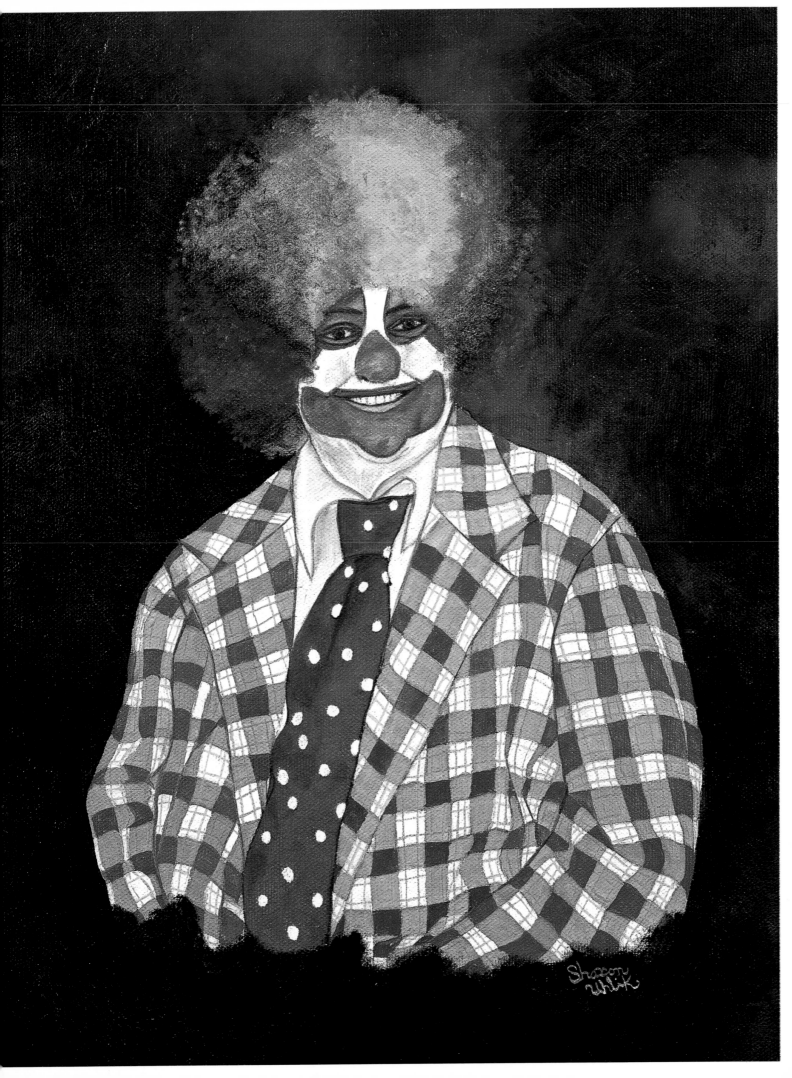

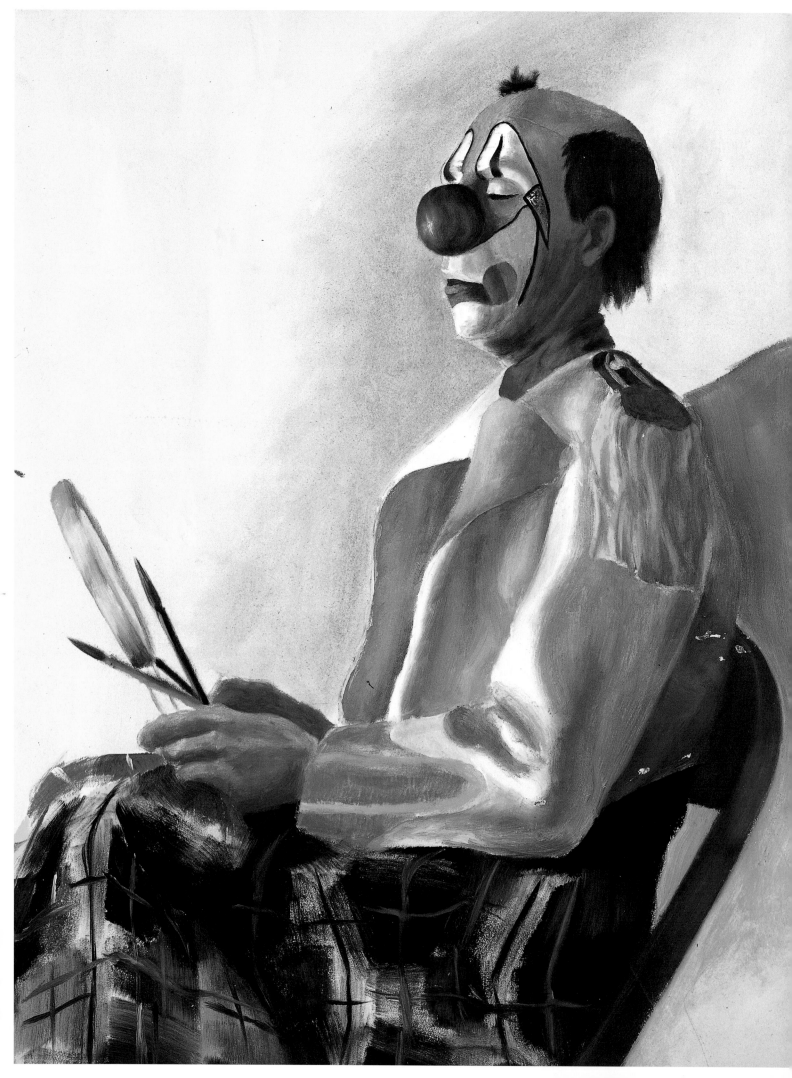

MAYBE IT'S GAS!

Somehow this clown painting sang to me in my own inner voice: "Jeeze, I don't feel like doing this today." People don't know the energy that goes into funny, and as a clown, funny is expected; funny, cute, friendly— all the things that don't look back at you from the mirror. I wondered, why the silent sigh? Had some bad news? Wife left him for leaving streaks on the sheets? Lost his shoes with the onset of Alzheimer's? Or perhaps, on that day, at that moment, he was just empty.

Or maybe it's gas!

WHOOPI GOLDBERG

THE SEX LIFE OF CLOWNS

Think of it: clowns paint their mouths with wide red bands, making them appear more open and inviting. Noses are extended, made larger and thicker, and painted in provocative colors. Hair on the head, which reminds the subconscious of genital hair, is puffed and combed, pulled sideways to great lengths, then dyed bold, eye-catching colors. Is there any doubt that the mating ritual of clowns is extravagantly beyond the practices of ordinary people?

Male clowns will often pick a drab female, then spend weeks or months convincing her of the appeal of slipping into a satin dress with bright orange polka dots. The clown will court her in full make-up, inuring her to the sight of him, slowly urging her to join him in the ceremony of the greasepaint. The relationship of male to female is the same as peacock to hen: the male, or Tom-clown, will dress in full regalia; the female, or She-foon, will reflect the Tom-clown's appearance, but to an understated, symbolic extent.

At the beginning of mating, the She-foon will sit on the edge of the bed while the male clown does handsprings across the bedroom. He will then sit in a pie. The pie symbolizes the male fluid, and by sitting in it, the clown fuels his erotic juices. He then removes his meringue-soaked lower garment, known as the Boopy-Doopy, puts it in a pre-addressed mailer, and sends it to Saudi Arabia.

The female then lies back on the bed and exposes her genitalia, on which has been painted an orange and green target. The tip of the male organ has been coated with red greasepaint. The Tom-clown steps back from the bed and flies at her three times, always missing and hitting his head on the headboard. Then penetration is attempted. It is the Tom-clown's responsibility to stay wide of the target, generating several false starts to which the female responds with "Wrong!" and "Nope!" Once penetration is achieved, the female shouts, "Do it, Bozo!" and the act is consummated. Afterwards, it is a custom, though not part of the ritual, for the clown to lie back on his bed and light an exploding cigar.

The sex life of clowns, like that of regular humans, is fraught with complications and complexities. Sometimes the female, in the last stages of courtship, will choose a published scientist instead. Sometimes ejaculation is premature because the clown suddenly imagines forty of his fellows crowded into a Volkswagen. It is often believed that ritualized sex makes courtship easier, that practiced rules don't require much imagination or personality. But debilitating failure, within the context of these conventions, is common for clowns.

I know.

I am one.

STEVE MARTIN

TOOTHLESS MODERN
CLOWNING

Where did we get the idea that children love clowns? When my own kids were little, they would start twitching nervously whenever we came within half a block of anyone in clown makeup, big shoes, and baggy, polka-dotted pants, and beg me not to get any closer. And by the time they overcame their fears, they were already too sophisticated to appreciate the mindless slapstick and manic buffoonery. Of course, *good* clowning (Harpo Marx or Cirque du Soleil) transcends the obvious limitations and banalities of the form. But we don't really see that much good clowning these days. It's as if we have some cultural memory of the clown that is more cherished in imagination than it is in practice. Like cotton candy—we buy it again and again, always thinking it's going to be better than it is. Did we ever really laugh at clowns? Rodeo clowns I get; they protect people from bulls. But I never understood what the clowns brought to the circus, except some colorful poster images and a way to keep the audience distracted while they changed the rigging or cleaned up the elephant poop.

I'm guessing that the tradition began with the court jester, the fool, or the *commedia dell'arte* (you look it up). But where these earlier forms may have served some useful satirical purpose, puncturing the pretensions and hypocrisies of their societies, challenging the established social order, or mocking authority figures, most modern clowning seems to have devolved to hair, makeup, and wardrobe—the garish, leering mouth; the fuzzy hair; the eyes open wide in perpetual astonishment; the clash of bright colored stripes, spots, and plaids. And for what? No longer satire or even burlesque, this toothless modern clowning misses the point of most great comedy—to mock us, to challenge what is, and to shred our righteous complacency.

HAROLD RAMIS

THE LIGHT
AND THE DARK

Clowns represent both the light and the dark.

They remind us that laughter and sorrow make us whole.

GOLDIE HAWN

BOZO
IS A HAS-BEEN

Because I made a movie about alcoholic clowns, people think I hate clowns. I don't hate clowns. I hate people who like clowns. Clowns to me are like John Tesh's music; I'm sure it's awful, but I just choose to ignore it, so it doesn't affect my life in any way. My movie, *Shakes the Clown,* was not supposed to be an indictment of the clown world. I was trying to make fun of stand-up comedians. People think it would be fun to hang around comedians. Sometimes it is, but most of the time it's brutal. We are a group of self-absorbed, self-hating, humorless pricks who are prone to deep, dark depressions (except for my friends and Ray Romano, who I hear is a very nice fellow).

Neither the clowns nor the comics got my movie. The clowns took it personally. (Was the movie too close to the bone? Maybe clowns *are* a bunch of murderous, backstabbing, cocaine-sniffing alcoholics?) Clown groups around the country condemned the film before it came out. Steve Smith, the president of the Barnum Clown College in Sarasota, was its harshest critic, issuing damning statements about the film before it was even released.

I was so excited. I knew the movie had zero money for publicity and the clowns would promote it for me. I had made the *Last Temptation of Bozo.* In fact, even Bozo came out against my movie on CNN. I retaliated against his comments by saying that "Bozo is a has-been who should be waving out front of a car wash." The harder I hit them, the more they promoted the film. There was an audible gasp from the audience on *Regis and Kathie Lee* when I called Ronald McDonald "a corporate whore." It worked. Soon *Time, Entertainment Weekly*, and *USA Today* all ran stories on the "clowntroversy." My little dirt-head film even made its way into Johnny Carson's monologue, two nights in a row.

It all peaked when, upon arriving to appear on the *Today Show* after a sleepless flight, I was told that "a clown is going to debate you on the show." I said, "I know, I've seen your program." I was then informed that they meant a real clown, not Katie Couric. The clown and I shared a small dressing room; his name was Bamboozle. We were very cordial to each other, but he seemed a little confused when I informed him I was going to rip him a new asshole when we got out on the air. He asked, "Why?" I said, "'Cause it's TV. It's not real. It's like wrestling." True to my word, when we got out there, the shit hit the fan. (Katie has gone on to claim on both *Rosie* and *Conan* that it was her worst interview ever. I take this as quite a compliment, coming from a woman who has to interview 'NSync with a straight face.) Bamboozle said something like "Clowns do a lot of good work for kids and Bobcat's film portrays them in a negative light." I said, "Nobody thinks clowns are funny. The only reason you perform in hospitals is because that's the one place a kid can't get up and run away from you." Katie started hitting me with her notes and asked, "Would you please be serious?" I said, "No, you're interviewing me and a clown. What happened? Did you lose a bet with Bryant?" I have said and done much worse things on talk shows, but I have never been asked back on the *Today Show.*

Most people get nervous when they see a clown, because clowns give off this vibe that they are going to make you touch their penis. I get nervous when I see a clown, because I don't know if he is going to slug me over something I said when I was trying to promote my low-low-budget movie. I have learned that clowns, like comedians, are very sensitive and lack a sense of humor about themselves. I guess it's easy to step on someone's toes when they're wearing size eighteen shoes.

BOB GOLDTHWAIT

GLOVES

Although I am a stand-up comic, underneath it all, I'm a CLOWN. I don't appear in totally normal clothing. There's the fright wig, the little boots, and mainly, the GLOVES.

All clowns wear gloves. Even Mickey Mouse wears gloves. I feel absolutely nude on stage without gloves.

It has something to do with grandeur of the human hand, our exclusive prehensile thumb, the beauty of it.

PHYLLIS DILLER

LAUGH AT
MY BIG, RED LIPS

DEAR DIANE,

SORRY THIS TOOK SO LONG, BUT SOMETHING VERY IMPORTANT HAPPENED TO ME WHILE I WAS WRITING THIS. I STARTED OFF OKAY, BUT THEN I DIGRESSED INTO SOMETHING I CAN ONLY DESCRIBE AS EXTRAORDINARY. I LEAVE IT INTACT AS IT CAME OUT.

In school, the class clown was the disruptive kid who had poor impulse control. He was always, always annoying me. The kid who made quiet, witty comments pointing out ironies of the lesson was funny. The difference between them is wit. Clowns are witless performers. They bombard you with "Laugh at my big, red lips!!...Okay, maybe my big, mismatched clothes will floor you!!...Hey, look at the unnaturally huge expression painted on my face!!" Being around a clown is like being poked repeatedly by someone trying to get my attention. I just want to swat them away.

Wait a minute, I have pretty strong feelings of disdain for clowns. This is interesting because many argue that *all* performers are ultimately clowns in some form. And as a performer, I'm mostly associated with "witless" characters. Maybe the disdain is for myself. Maybe it's a monotonous loop of self-loathing channeled into performing for love and attention. (That's a pretty common psychological analysis of performers.) Oh God, I'm common on top of everything else. I have to fix this. I have to change. I need to break the cycle, just break the cycle. Get out of this go-nowhere loop so I can truly love myself—MY SELF. I'll be the opposite of what I am now. I'll become...an attorney, a TAX attorney!

WELL, DIANE, THAT'S IT. THAT'S WHAT HAPPENED TO ME THROUGH YOUR BOOK—THROUGH TAKING A LONG, HARD LOOK AT CLOWNS!! GOD IS TRULY EVERYWHERE. THANK YOU, DIANE. I'LL ALWAYS CHERISH THE TIME I GOT TO WORK WITH YOU. IF YOU EVER HAVE ANY PROBLEMS WITH THE IRS, I'D LOVE TO HELP. I'LL BE LISTED AS LISA KUDROW, 'CAUSE THAT'S, YOU KNOW, MY PROFESSIONAL NAME. WHO KNOWS, IT MIGHT BE GOOD FOR BUSINESS—MAKE THE ACTING PAY OFF SOMEHOW—TURN A "WRONG" INTO A "RIGHT."

SINCERELY,

LISA KUDROW

WHAT CLOWNS DO

Growing up in Sarasota, Florida, former winter headquarters for Ringling Brothers and Barnum & Bailey, I was influenced a lot by the circus. When our family started hearing explosions in our new neighborhood and took a walk to try and find out what was going on, we saw a man flying through the air between two houses. It was the family that shot each other out of a cannon. When my sister and I went trick-or-treating our first Halloween in Florida, we randomly knocked on the door of the Doll Family and I saw my first little person.

Sometimes I'd take the long route to school on my bike so I could ride by Emmett Kelly's house. I never saw him out in the yard or through a window, but I'd seen him on television plenty. I was never attracted to classic mime, but clowns like Emmett Kelly and Red Skelton intrigued me. It wasn't until years later that I realized that a lot of what clowns do *is* mime.

When my family visited our cousins' grandparents, I would spend as much time as I could in their garage studio where he labored at his hobby, drawing clowns with colored pens. He gave me a few of his pictures and that began *my* clown painting collection. I think it was also around this time that I first heard the term *class clown*—in reference to ME! I never really quit "clowning around" and although I didn't go on to apply the traditional makeup, I became one.

PAUL REUBENS

A PURE REFLECTION OF YOU

It is the dark heart of the clown that I like—the trickery of the painted smile and the glint way behind the black-saddened eyes.

Clowns are negatives—they're dark where the image itself is light, and vice versa. When you laugh at them—at what's so unbearably true and deviously marked and then hidden—you are standing in the Conundrum of Consciousness, the un/holy paradox.

Clowns are Tricksters and the number of the Trickster/Foole/Clown is Zero—the number of cleansing Magick.

The clown is a pure reflection of you. Its highest role is to lead people to G-d, its lowest role, to humiliate.

I'm no fan of clown paintings. They always seem to lack and, perhaps, purposely ignore the sting that clowns actually leave behind in the unconscious mind of the beholder.

ROSEANNE CHERRI BARR

BARBEQUE, JESTER STYLE!

When I was young (those ten minutes before, and in, Las Vegas), my mother played a clown in her nightclub act (an act I soon joined, as this was our family's version of a "family outing"). My mother donned a clown costume, complete with red nose, clumpsy hat, and large, awkward shoes. As a kind of climax number to the show, my mother, joined by back-up dancers Harvey Evans and Jerry Antes, sang "Make 'Em Laugh," Donald O'Connor's famous number from *Singin' in the Rain*.

This was the last time I remember my mother's hair, her actual hair, however sparse—no wig. Those came later. She danced. All three of them did, in their big, black, floppy shoes. I frequently sat in the wings and watched this joyful romp, this twice-nightly nonsense—my mother, so seemingly exhilarated, so girlish, so young. But then, what could she have been? Thirty-something, the age of exuberance? Half-past-something in clown time, when you can still dance for all you may, or may not, be worth.

The clown costume seemed to bring out the best in my mother. The most honest garb for her eager demeanor, luring you into the world of this cheerful, persuasive love of her—the performed personality, the "I'll meet you at the top of my lungs" lady. I sometimes beg her to put a clown costume on now—late at night, when she's more prone to regretting (a decidedly unclown-like sport).

But overall, she has a persona that's infectious. And it was one I caught a strain of almost unwittingly, coaxing people to their doom in delighting in someone (me!). But that was its ever-sharpening point. See how cute? How smart? How funny? The funny has always saved me. Even if it sometimes feels as if I have to drag it out of me by its Achilles' hair. The females in the funny family—captivating, counterfeiting, whatever it took. And it could and would take plenty—unfortunately, just not weight. Where did all the time go, but oops! You're still chubby! Sorry!

Who were we besides all that when the noses came off? The wigs? The makeup? When the audience went away, leaving the bloat and a desire for cigarettes? The eyes often gave it away. Above the grin, the funny talk, the story—lost eyes, tired, typical sad clown stuff. The sad funny. Awww—poor clown. Sweet, childish, with the drawn-down mouth, heading south, a tear, a ragged hat, a wilted flower in the hand. Shy, almost sorry for something.

Clowns are a bright option for some, an irritant for others. For me, they're the colorful hairball my history refuses to cack. So, I just live with them as a present, tied with the bow of whatever once held my pants up.

I'm not even ambivalent about clowns—except when I am. Where there are clowns, there's fire. To warm your head, your heart, your hands, or to simply burn down the burdened situation. Barbeque, jester style! Bring your kids, and leave your teeth and regrets at the door—we're celebrating in Clownland, the Clownified Clownship!

CARRIE FISHER

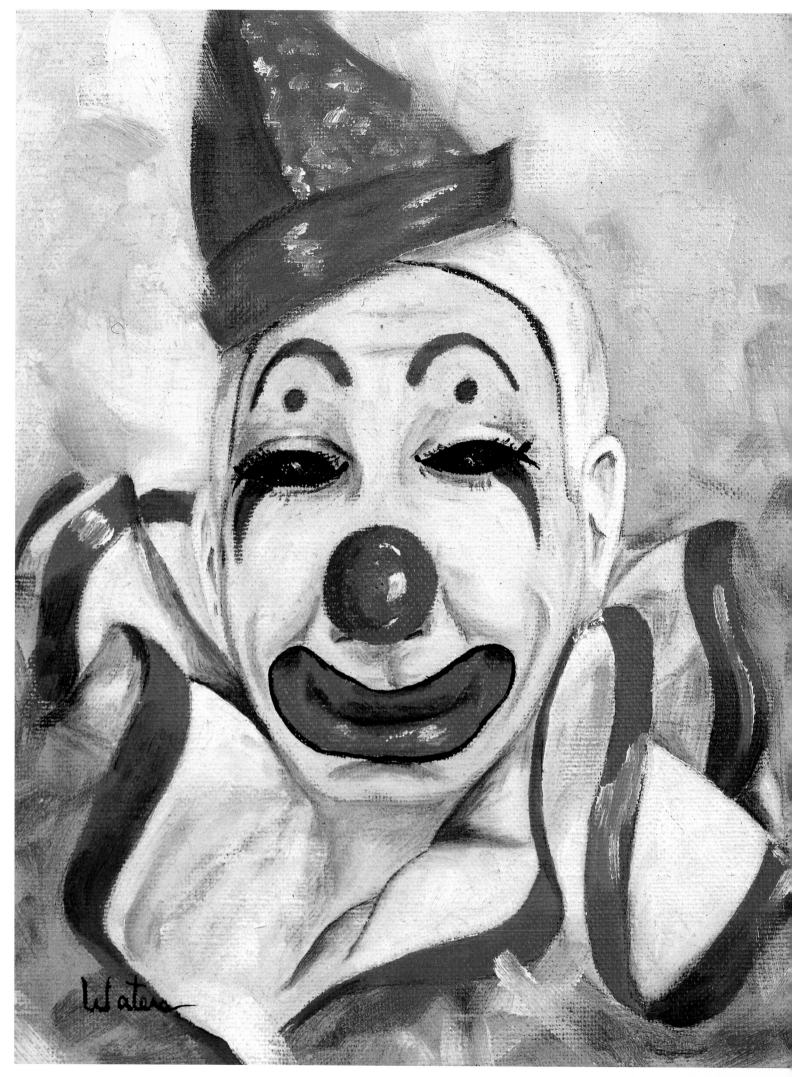

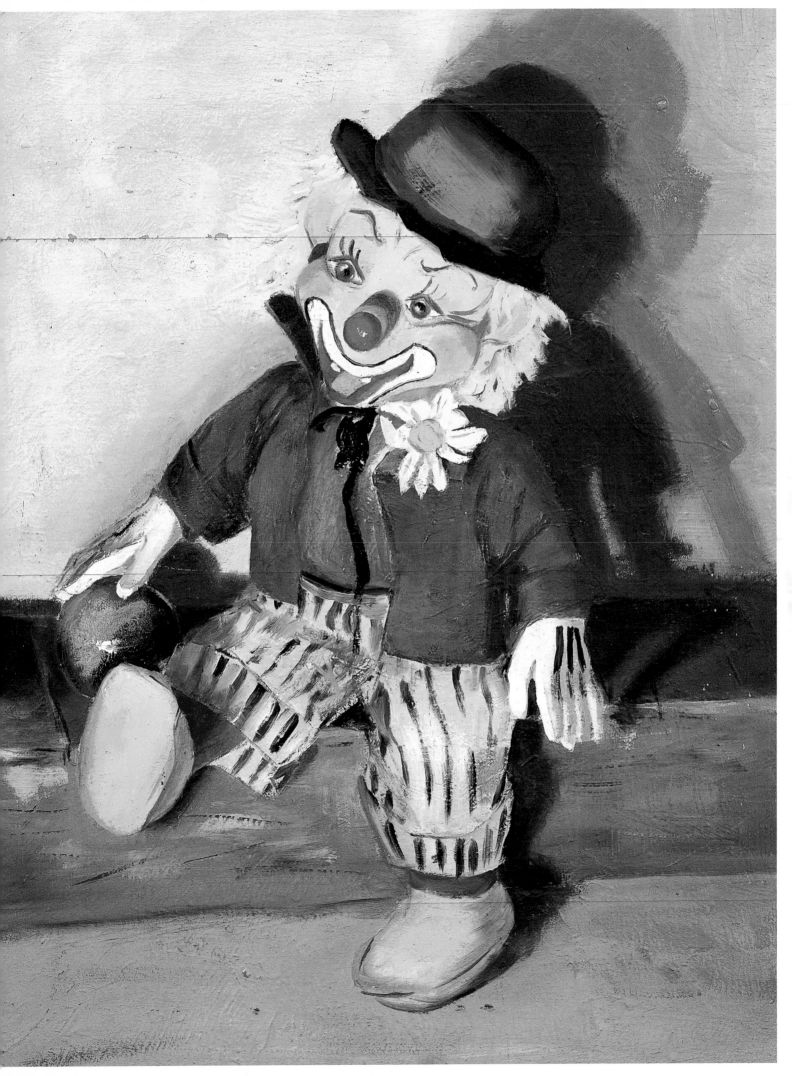

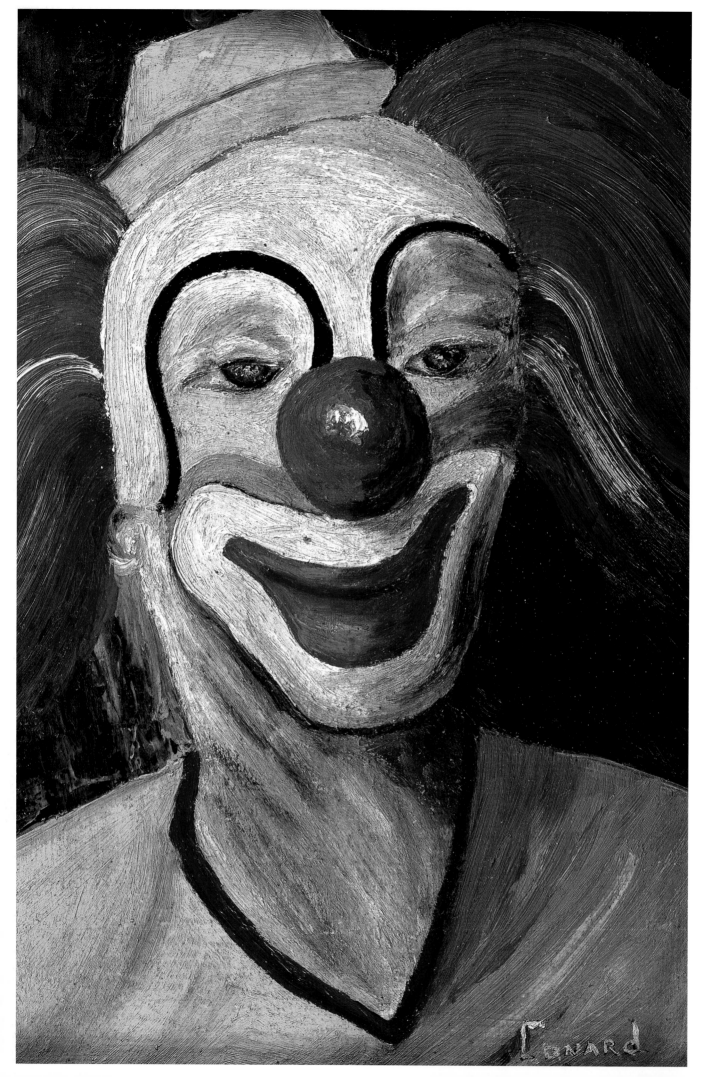

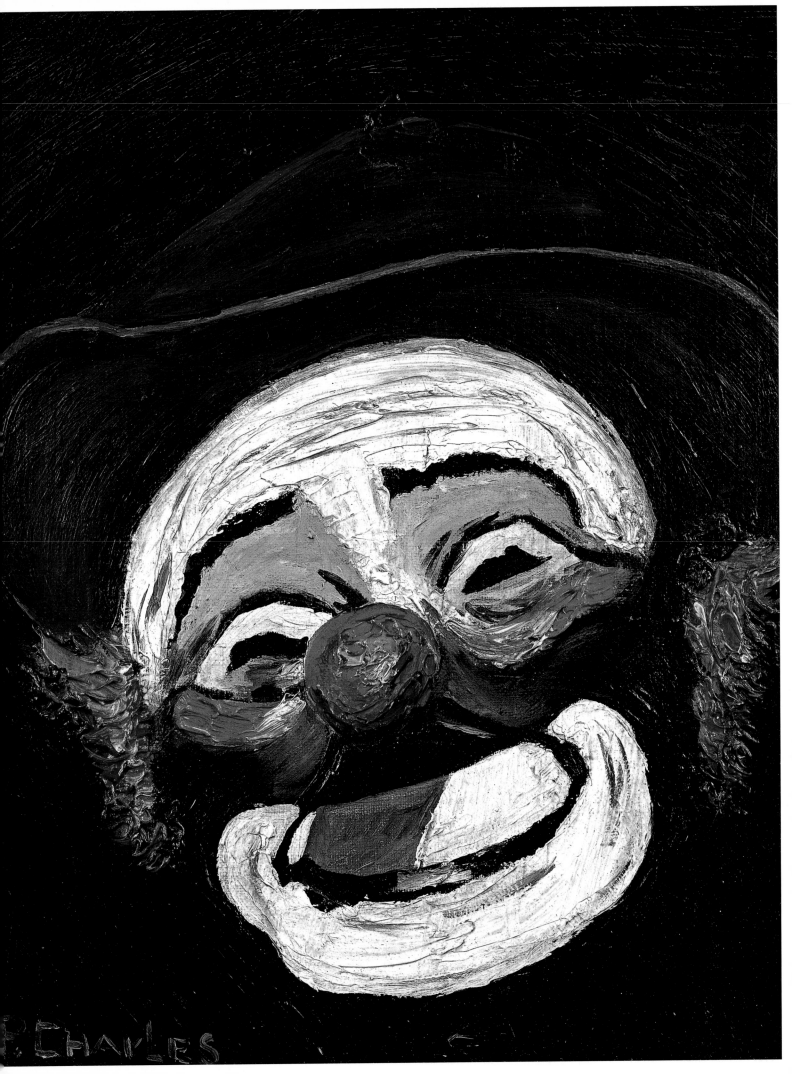

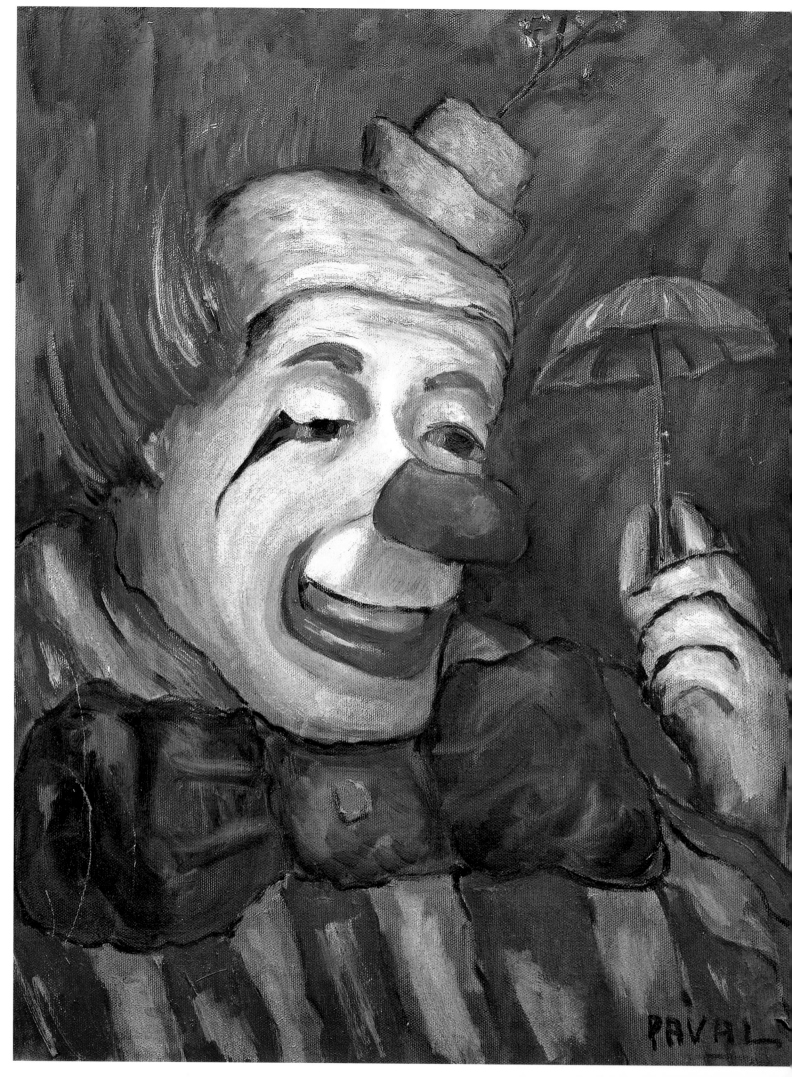

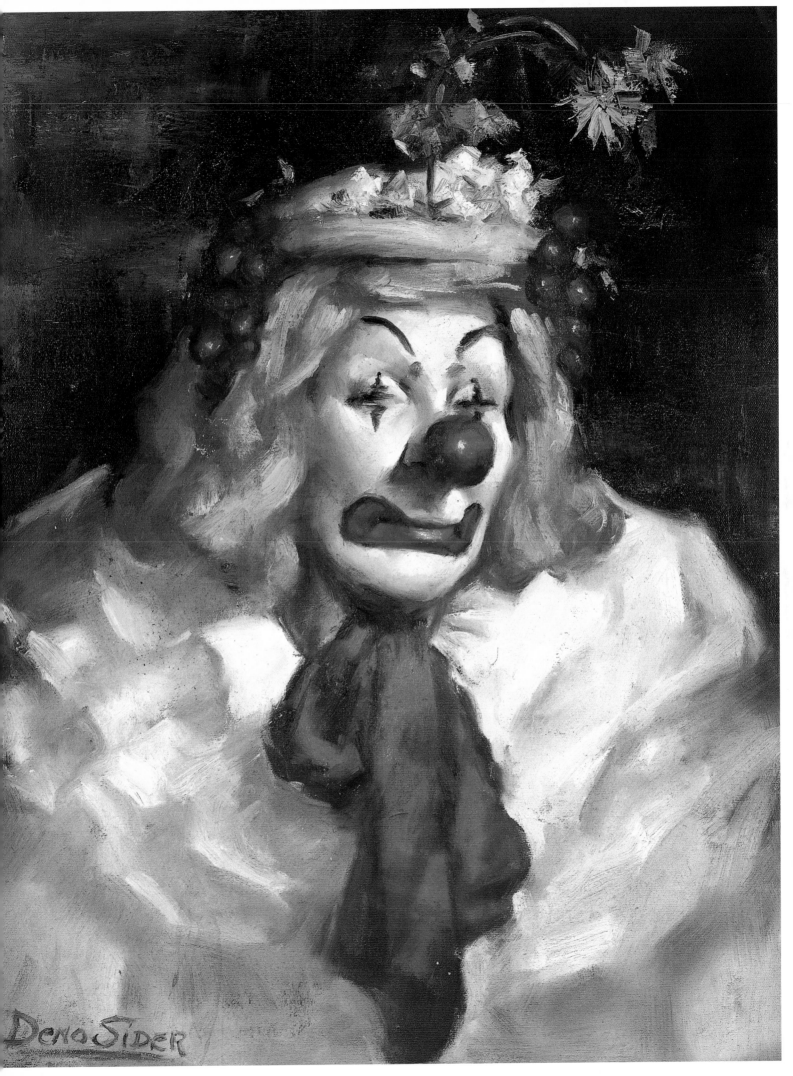

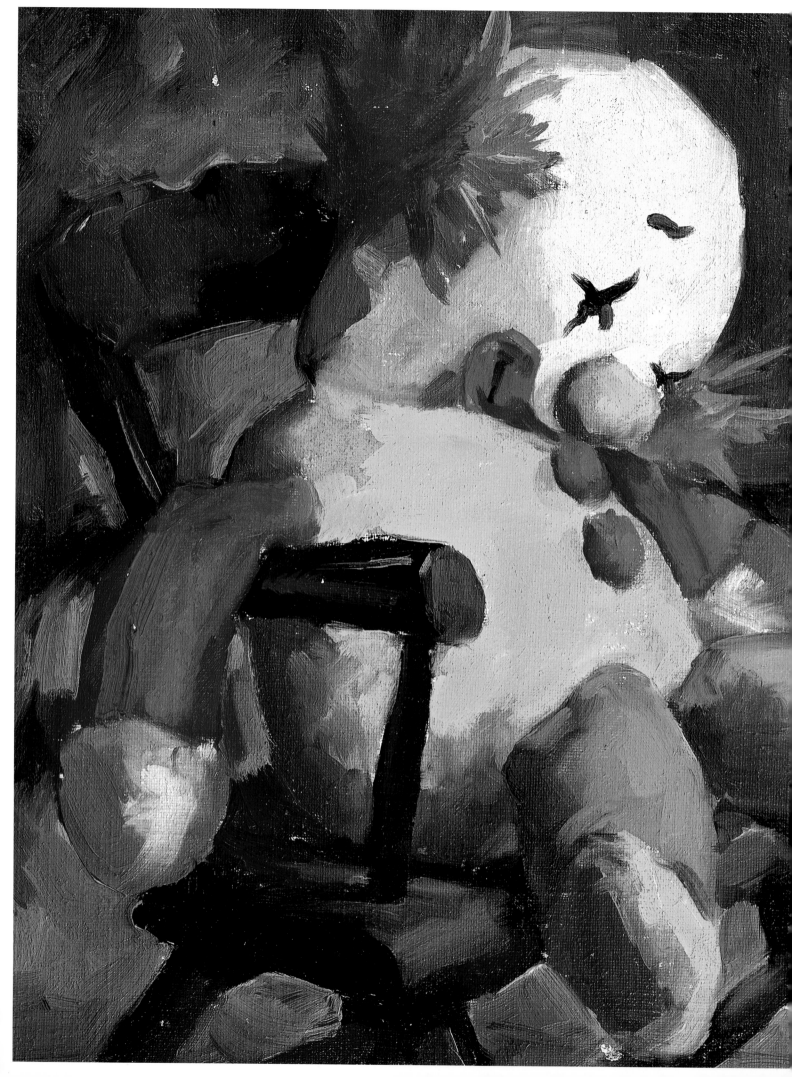

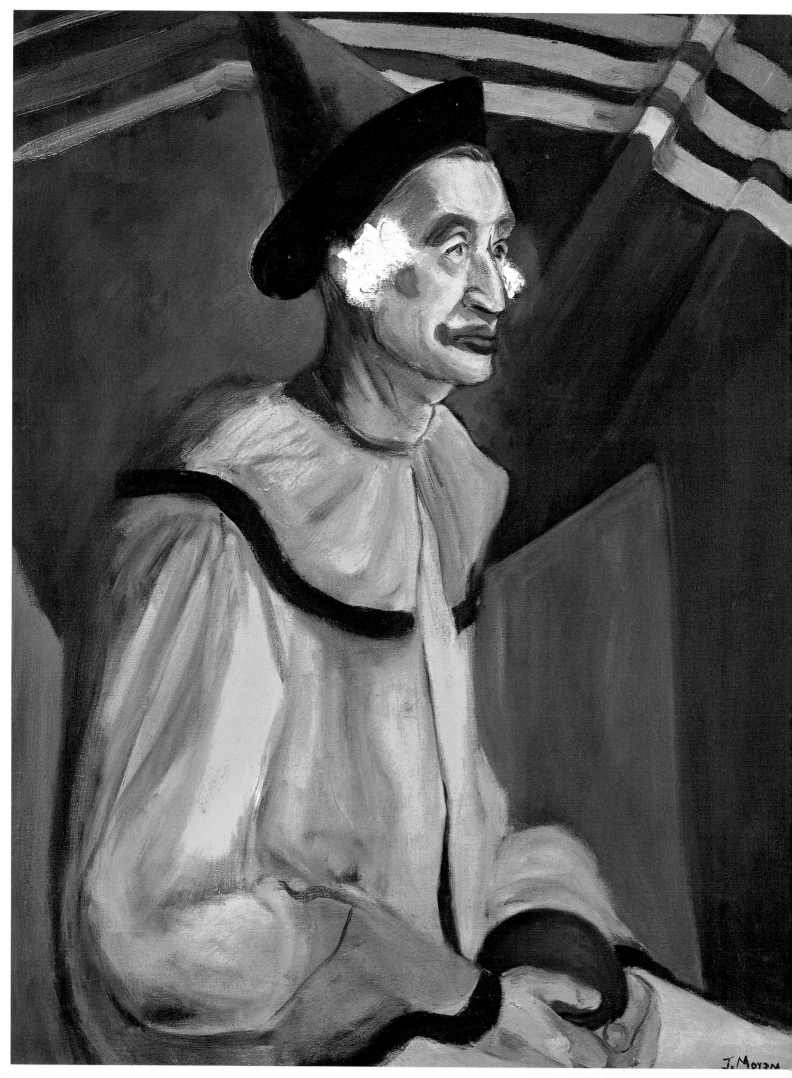

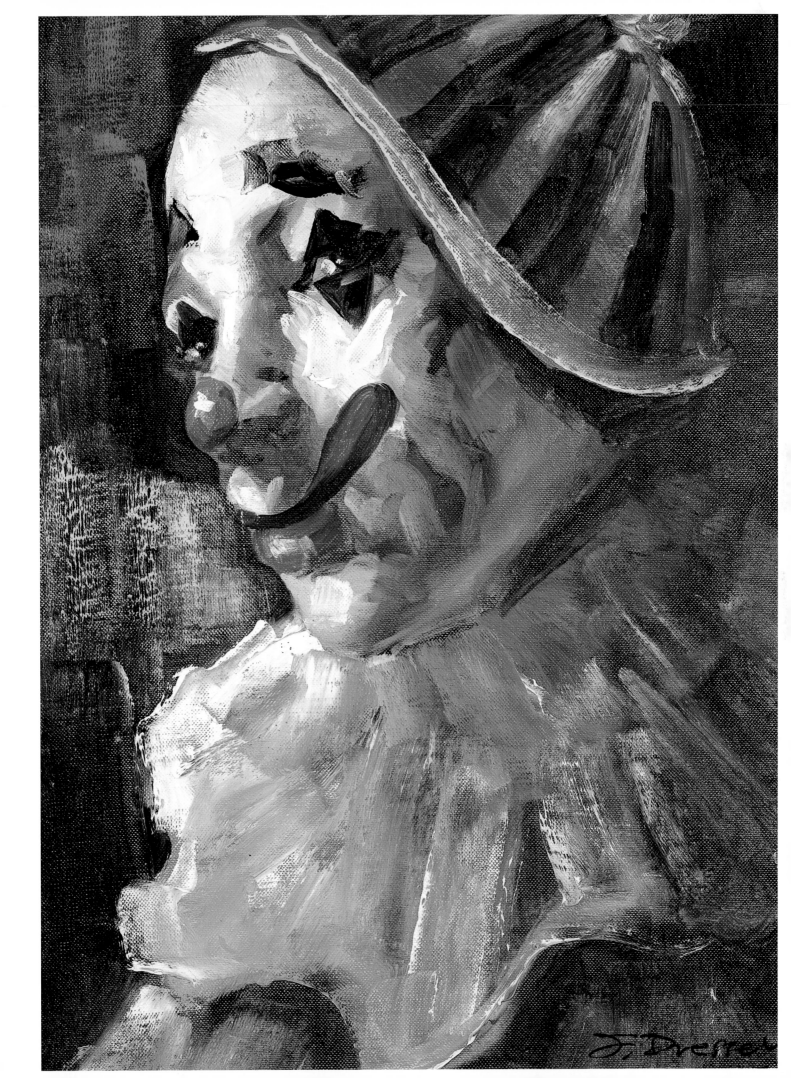

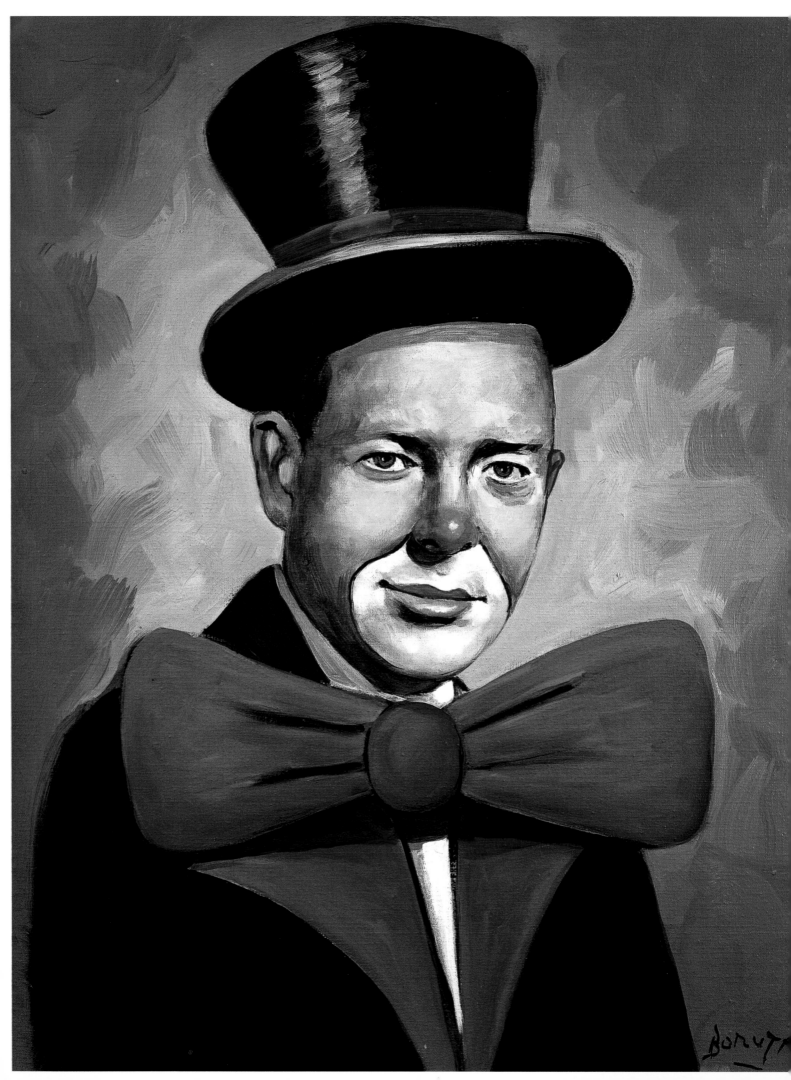

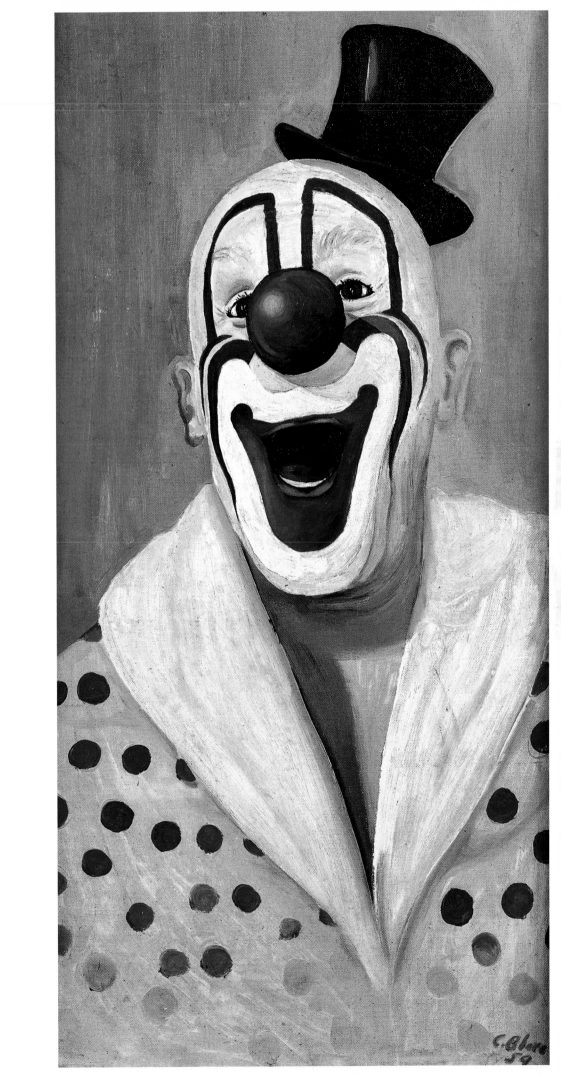

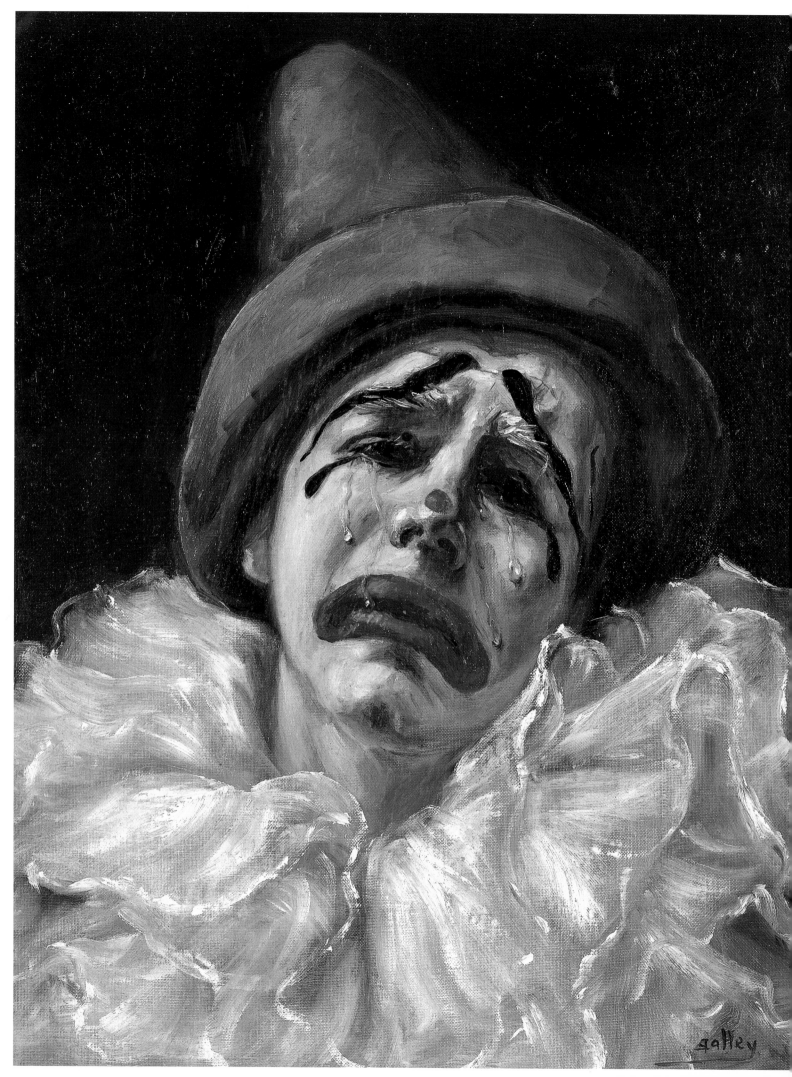

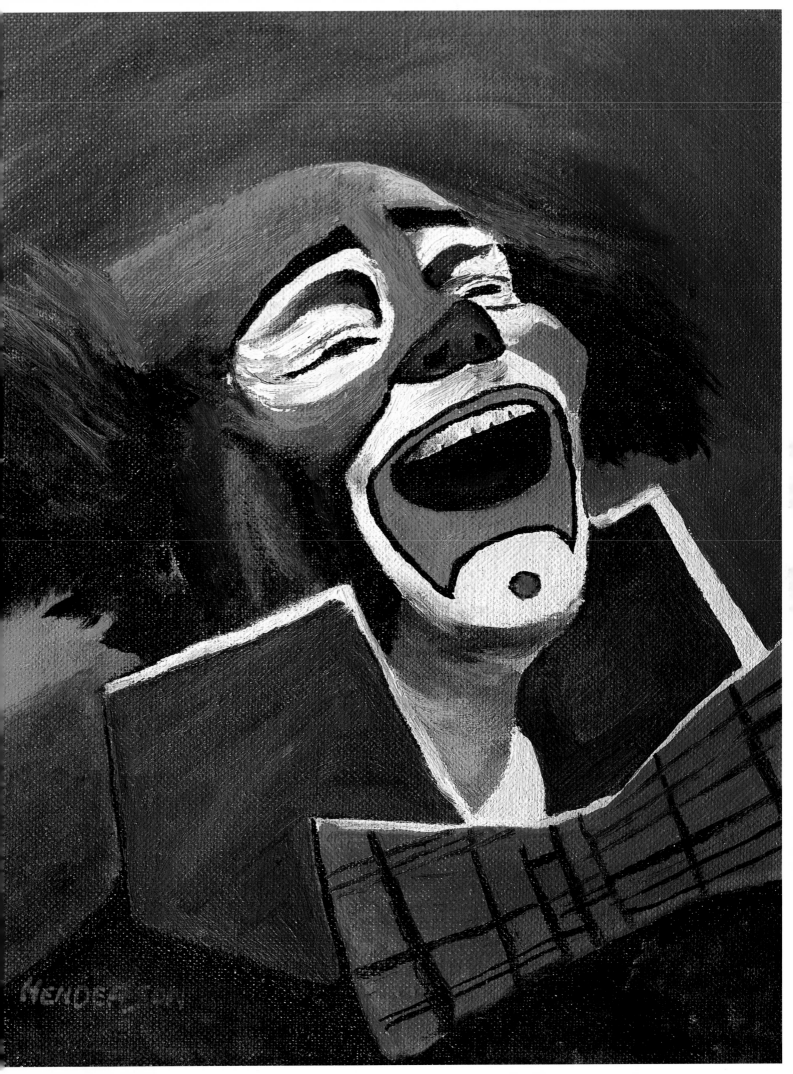

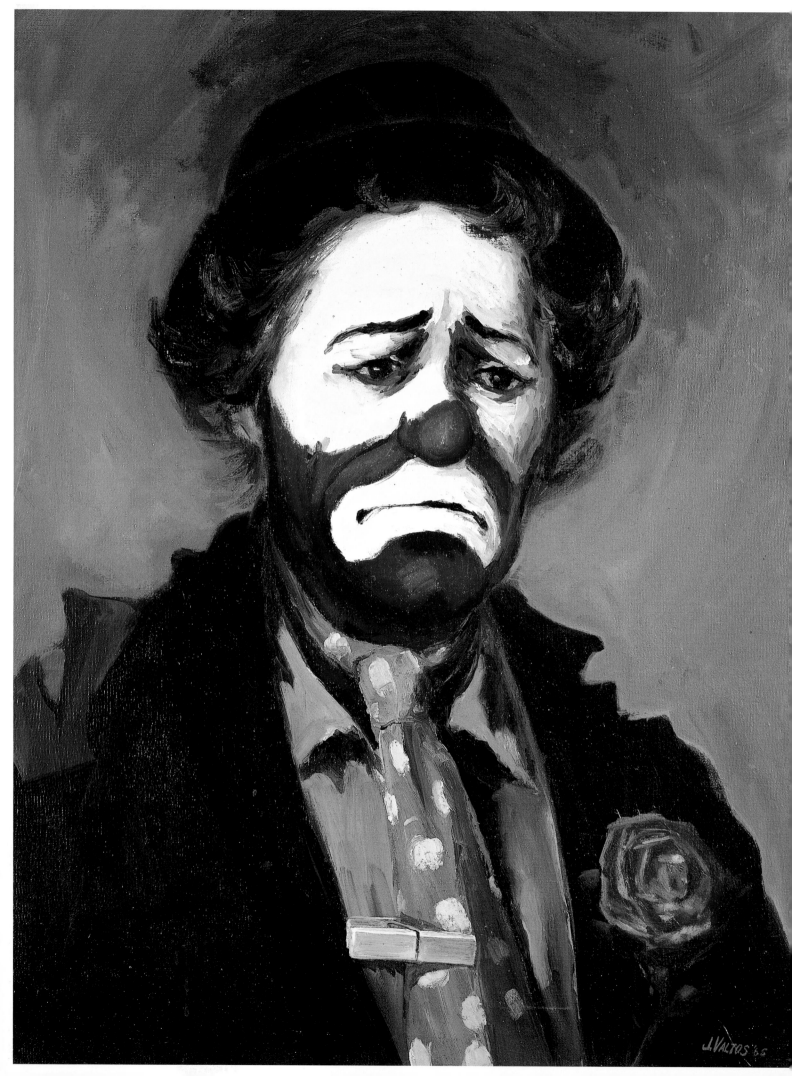

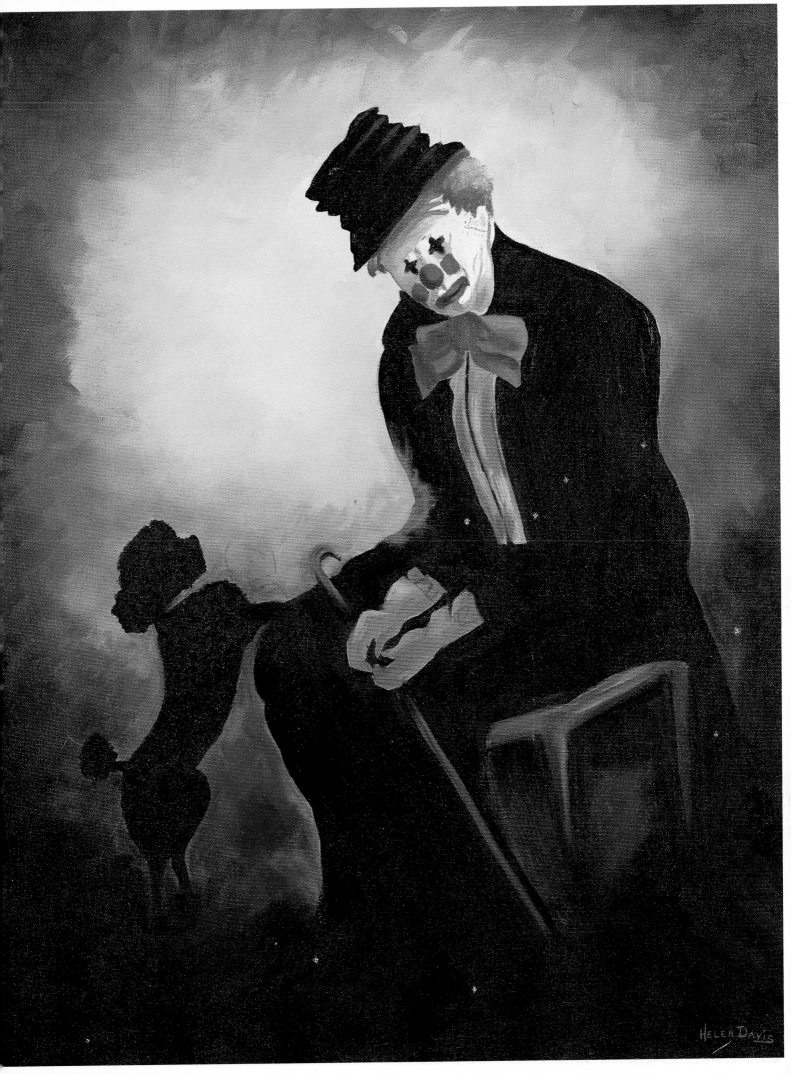

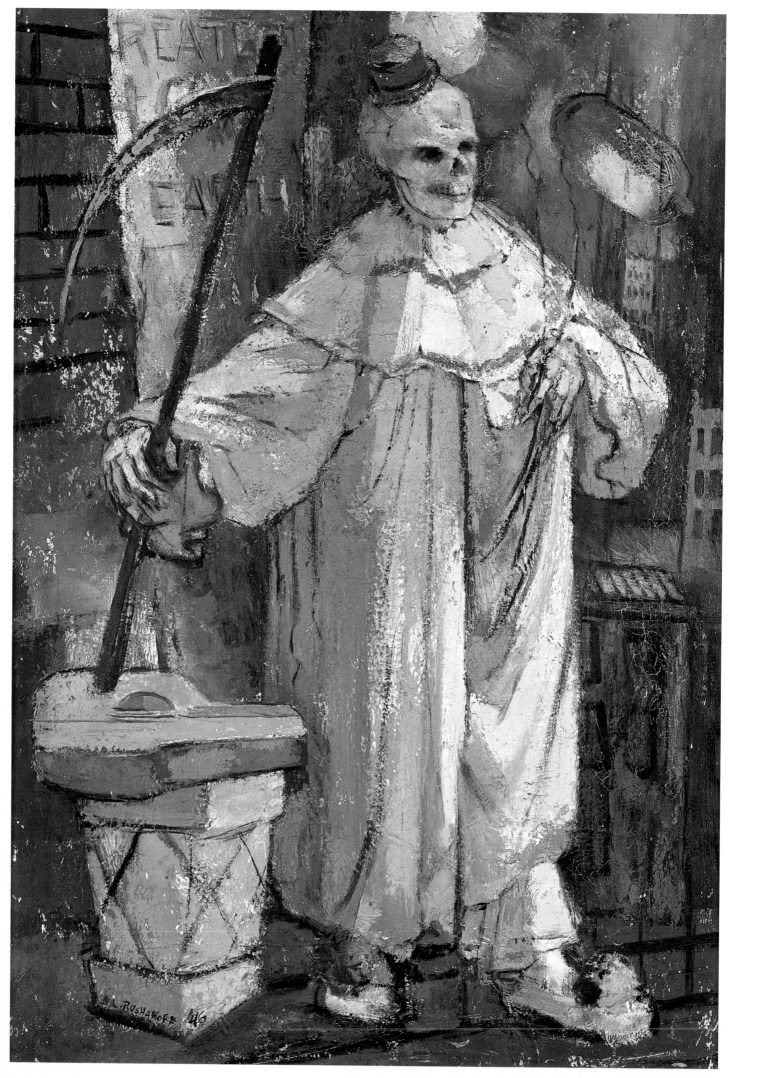

THE ULTIMATE JOKE

Through the image of death, the jester's light upon the fate of man becomes the ultimate joke on us.

MICHAEL RICHARDS

THERE'S GOD IN EVERYTHING

I can't look at a photograph of myself because I see right through it. I see the struggle, the past loves, the hopes, the dreams, the failed *Tonight Show*s, the bad dates—all there on my face. And I'm not even a clown. I'm just a comedian. Oh sure, there was that one day as a boy in my hometown of Tucson, Arizona, when a rodeo clown coaxed me to crawl into a barrel on top of him. "This isn't my style of comedy," I remember screaming. "It's too broad! Get off me!" I've been confused and yet oddly attracted to clowns ever since.

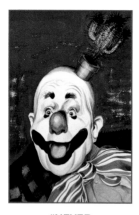 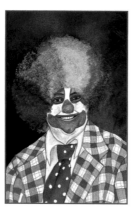 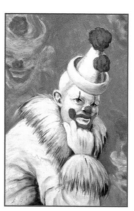 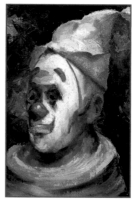 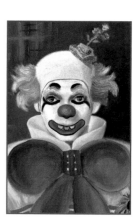

"NEVER BAR MITZVAHED."

"TRIED ANTI-ANXIETY MEDICATIONS BEFORE THEY WERE APPROVED BY THE F.D.A."

"STRAIGHT AND ANGRY ABOUT IT."

"FELL IN LOVE WITH A WOMAN WHO TURNED OUT TO BE HIS MOTHER."

"NEVER MADE THE SWIM TEAM."

All of one's inner life manifests itself physically. And with clowns, there's the makeup, fake hair, big pants, big shoes, and, I assume, big socks. What are they hiding? If I met a woman who looked like that, I'd run, and I have. It's like one big emotional red flag yelling, "Stop, don't get intimate with me!"

Historically, it's not unusual for men to dress as women for a laugh. Look at Milton Berle. But that was just a gender turn. Clowns seem to have taken it to a whole new level—past the lipstick, heels, and dress. The mystery is, why? What is going on in the mind and spirit to cause this? These questions, I believe, are what make clown paintings so compelling. Seeing what must be pain, loneliness, and untold secrets so disguised for, of all ironic things, a laugh.

There's God in everything, and somewhere deep inside the morass of the clown artifice, is God. I've taken some of the paintings and attempted, with my great understanding of psychology, to diagnose what may have been the core dysfunctional issue that triggered the whole thing.

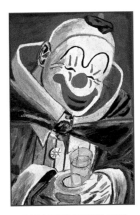

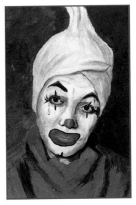

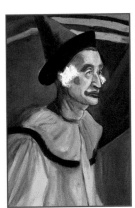

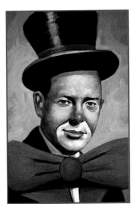

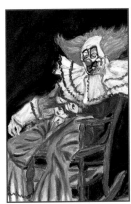

"HEALTHY ENOUGH THAT HE DOESN'T NEED A CLOWN OUTFIT, BUT NOW HE'S 'LOCKED IN' BECAUSE HIS FRIENDS WOULD NEVER RECOGNIZE HIM WITHOUT IT."

"FOOD ALLERGIES."

"FRENCH."

"CAN'T COMMIT."

"TOTALLY NORMAL UNTIL 9/11."

GARRY SHANDLING

CLOWN ENCOUNTERS

Big Nose

Big Feet

Broken Balloons

Birthday Gone Wrong

ROBIN WILLIAMS

YOU CAN SAY NO

DIANE AND I TRADED CALLS FOR A WHILE. THEN WE CONNECTED.

DIANE: I'm doing a book about these bad clown paintings....I'm asking people to write a little thing about what they think about clowns. There's an easy way out of this....You can say no.

I PAUSE AND THINK: Clowns aren't scary....Wait, that's a bunch of baloney....I got really great tickets to the circus once while I was on *Taxi*. A clown blew a horn in my two-year-old daughter's face and screwed up the whole experience for her. Hey, he was just doing his job. Sometimes they're funny—when they all come out of a car, or hit each other on the ass with a board that makes a whacking sound. Rescuing each other from burning buildings is big too. I love the Cirque du Soleil clowns....The guy who leans way far forward when he's conducting, but doesn't fall over....

AFTER LONG SILENCE:

DIANE: DeVito, what's going on? What's happening? Something good? Something great? Has it got to do with clowns?... You're remembering something?...

A PAUSE. I DON'T SAY ANYTHING BECAUSE I'M WRITING DOWN WHAT SHE SAID.

DIANE:...YOU'RE CRAZY! Did something happen?

A LONG SILENCE. I'M STILL WRITING.

DIANE: Well, this is a first.

DANNY: What's your name?

DIANE: OH, SHUT UP!

I WAS HAPPY SHE CALLED ME....
THE NEXT TIME I SEE HER, I'M GOING TO SQUEEZE HER NOSE.

DANNY DEVITO

DO THEY DREAM DIFFERENT DREAMS?

I have always been in awe of clowns. When clowns leave behind the roar of the circus tent, the adoration of a birthday crowd, and wander home, how do they feel? Do they sleep in clown beds? Do they dream different dreams? Do they smell funny? Who lurks behind the lonely and frustrated faces? Perhaps the lady clowns, comfy and ready to tickle and enchant, are women who like hemp and herbal teas, macramé and big, fluffy kitties, beanbag lavender eye pillows and rainbow coffee mugs. Or maybe male clowns sit on porches whittling sticks, splashing on Old Spice aftershave, frying up a breakfast of Canadian bacon and hash browns.

There is a clown I know; he lives in the Valley, standing tall at the corner of Burbank and Vineland. A goofy sentry with squinty, evil eyes, he offers up the special of the week at Circus Liquor—vodka, gin, beer, wine. Is it appropriate for a clown to hock booze in North Hollywood?

SANDRA BERNHARD

I HATE CLOWNS

I hate clowns.

I have always hated clowns. From childhood on I found them uninteresting, predictable, pathetic figures, desperately begging for laughs after doing something no intelligent person would do—such as continuously walking onto the wrong ends of rakes; buying cars that could never hold all their family members; throwing buckets of confetti onto enemies, thinking that was going to stop them; or riding tricycles that any clear-minded individual could see were too small to get them anywhere. Ha. Ha. Ha. Not.

There is also something terribly frightening about clowns. The way they juxtapose colors, totally negating reality by painting a second surrealistic reality over the first comforting one. Gone is the coziness and the safety of unadornment. Clowns make us search too hard under their garish pigments for glimpses of familiar features or welcoming smiles.

Clowns never make me laugh.

Clowns insult our intelligence by trying desperately to play on our emotions. "If I can't make you laugh, it's okay because, underneath, I'm really just a shy, sensitive person. So, come on, be kind. See this tear on my cheek? Smile, giggle, applaud me—not because I am genuinely entertaining, but because you feel sorry for me." This is humor? This is a cheap plea for acceptance. Out, out, damn clowns. You deserve to be banished to black velvet and hung in double-wides between big-eyed children and dogs playing cards.

"All the world loves a clown"? Not this chicken. The world needs wit and intelligence and plays on words and misconnections of ideas—*but not clowns.* Any person who doesn't know his correct shoe size or where his true lip line is or hasn't enough sense not to dye his hair red or green or blue if he's over seventeen will never sit at my table. "Bozo"—I hope never to see that name on one of my place cards.

Attention, clowns of the world: you have taught me nothing, except to avoid the obvious when trying to make audiences laugh. I hope you've saved your money. I hope you will all see a doctor about the rosacea on your nose. And most of all, I hope you will all send a couple of bucks to Pierrette, who found out, sadly, that the *only* place Pierrot was funny was in bed.

JOAN RIVERS

I HATE CLOWNS

I hate clowns. I've always hated clowns. Even as a little boy, when my playmates guffawed at the antic high jinks of some Ringling Brothers merrymaker, I found the clown's turn an excruciating stage wait. And I was not one of those kids who was frightened by clowns, just numbed into a torpor by having to endure Emmett Kelly try to milk laughs by pretending to sweep the spotlight up with a broom. As far back as eight or even six, to get stuck watching a gaggle of grease-painted over-doers pile out of a tiny automobile was a punishment equal to thumbscrews. When my parents doubled up with laughter over some bulbous-nosed, wooly-haired creature in baggy overalls making horn sounds by squeezing a rubber bulb and acting zany, it only confirmed my long-held suspicion that I was adopted.

By clowns, incidentally, I don't mean silent movie clowns like Chaplin or Keaton or even Harpo, who were a totally different phenomenon. I mean classic, big-top clowns, or the kind that carry on at ballparks or children's parties, or dress up as giant mice or beagles. I don't mean to suggest that they are bad people or unskilled; it's just that what they do unfailingly has the same effect on me as Nyquil.

The only thing I hate worse than clowns are clown paintings, although I will admit some of the ones in this collection are surprisingly pretty. Still, I would be happy never having to suffer another round of jolly shenanigans from some cuter-than-life ball of energy in whiteface and oversized shoes. When it comes to images immortalized on canvas or black velvet, rather than clowns, my vote goes to something Rubenesque, unencumbered by costume and preferably blonde. Even at eight I knew they had to be more fun than the goofiest buffoons.

WOODY ALLEN

I LOVE
CLOWN PAINTINGS

When we think of the bulbous red nose of a clown, we think of laughter. When I think of that nose I think of one of the great sad clowns, Emmett Kelly. He made pathos an art to me. I've always used that nose and that emotion to my advantage.

I love clown paintings. There is so much humor, sadness, and pride. To me, the paintings of clowns show...character! Yet, as beautiful as they are, the paintings of clowns rarely give a correct idea of who clowns really are—except to those who have known clowns.

I know them. I am a clown at heart, in body, and in mind. I'm proud of that.

JERRY LEWIS

MY FIRST
COTTON CANDY

While sifting through these paintings a number of times, I couldn't help but recall an incident from my youth when I attended the circus at Madison Square Garden with my father. As I was about to experience the pleasures of my first cotton candy, I was smacked hard in the face by what proved to be a rubber mallet, wielded by a man wearing grotesque make-up and dressed in a loud polka-dot costume. That same fellow, I might add, later squeezed his bulb-horn directly into my right ear, causing me to flee the arena in horror.

My thanks to Diane Keaton for giving me this opportunity to revisit an incident that I have worked so hard to forget, lo these many years. I would encourage her to find a new pastime, one that does not include the collecting of these monstrous and hideous clowns.

LARRY DAVID

YOU MIGHT SEE YOURSELF

After learning that one of Hollywood's most important directors was in the audience of *The Producers* one night, I joked to Matthew Broderick that he probably wouldn't come backstage afterward because he wouldn't know what to say. "This isn't acting to him," I said. "We're like birthday party clowns!" To which Matthew replied, "Aren't we?"

The word *clown* has always made me cringe slightly, let alone the sight of them in the flesh or on canvas. When I was asked to contribute to this collection, visions of punch lines danced in my head. "I suppose the art history of Dogs Playing Poker had already been snapped up." Or "Perhaps it's time for *Father of the Bride III*."…And then I looked at the paintings. And I thought, maybe they have a point. My deepest fears were also confirmed. I am a clown.

Let's face it, clowns have been a part of society from the very beginning. I'm sure there was some drooling Neanderthal who felt compelled to hit himself on the head with his club in order to amuse his fellow cave dwellers, and I'm sure they were still laughing when he was eaten by a dinosaur. Sometimes comedy can be painful.

So, whether I like it or not, I am a member of the clown family. I have followed countless others out of some tiny little car and made my way in the show business circus. And the outrageousness of being one and what lies beneath can be found in these paintings. It's better not to discuss them, just as it's always better not to discuss comedy. Think of this as a beautifully assembled Rorschach test and see where it takes you. You might see yourself. And if you do, I'd be happy to help you get in touch with a top-notch mental health professional.

NATHAN LANE

GOD BLESS ALL CLOWNS

Let me tell you the truth. I *love* clowns and I love clown paintings, even the bad ones. But I never laughed at a clown in my whole life.

Before I ever went to the circus, I used to go to Saturday matinees at the movies and sit and watch Laurel and Hardy and Buster Keaton over and over again, until my mother came and dragged me home at night. You know, they made me laugh because of their deadpanned earnestness. They strove so mightily to function in the world, just like everybody else, but somehow, they never quite got the hang of the rules of life. In short, they weren't *trying* to be funny.

And I think that's why I always took issue with circus clowns—the big gestures, the costumes, the crazy makeup, everything. Pantomime is overdone to me. Everything they did screamed, "THIS IS FUNNY STUFF!" They were simply trying *too* hard to be funny, and that never appealed to me.

I once appeared as a clown with Ringling Brothers and Barnum & Bailey at Madison Square Garden. There was a clown there who broke with tradition and "gave" me a makeup of a clown, a famous clown, who has since passed away. I didn't realize that clown makeups are retired, the way football players' numbers are, when they die. Anyway, I was very kindly treated, taught a few little tricks of the trade, then pushed out into the ring. And to tell you the truth, after about fifteen minutes around that tanbark, I was ready to drop from exhaustion. And I was a kid! These other guys were all in their sixties and, I think, better. So, clowns have my respect and admiration, but they still don't make me laugh.

I did the eulogy at Stan Laurel's funeral back in 1965, and I read a little poem. I never did find out who wrote it, but I dedicated it to Stan. Let me just throw it in here for fun:

GOD BLESS ALL CLOWNS
WHO STAR THE WORLD WITH LAUGHTER
WHO RING THE RAFTERS WITH A FINE JEST
WHO MAKE THE WORLD SPIN ON ITS MERRY WAY
AND SOMEHOW ADD MORE BEAUTY TO EACH DAY

GOD BLESS ALL CLOWNS
SO POOR THE WORLD WOULD BE
LACKING THEIR PIQUANT TOUCH, HILARITY
THEIR BELLY LAUGHS, THE RINGING, LOVELY MIRTH
THAT MAKES A FRIENDLY PLACE OF THIS EARTH

GOD BLESS ALL CLOWNS
GIVE THEM A LONG, GOOD LIFE
MAKE BRIGHT THEIR WAY
THEY'RE A RACE APART, ALCHEMISTS MOST
WHO TURN THEIR HEARTS' PAIN
INTO A DAZZLING GESTURE WITH THE HEART

GOD BLESS ALL CLOWNS

DICK VAN DYKE

THE DAMN CLOWN IS
CRYING

Most people hate clown paintings. It's not just that they are bad; they are contemptible paintings. As I contemplate these sad, sick, and sorry paintings, they arouse in me a vague fear, not just of clowns but a cultural fear, an anxiety that perhaps *I am missing something.* But the strangest response I feel toward them is violence. I want to hurt them. Me, a well-balanced quinquagenarian, ex-part-time transvestite comic.

How do I explain this? What is going on here? What is so frightening? I don't feel this way about other forms of bad art. I like the 3-D Jesus cards, the kitsch crucifixions, and the day-glo *Last Supper*s. I don't react violently to acrylic tourist paintings; I can pass endless seascapes without a murmur. I even *own* a velvet Elvis for God's sake. What is it I find so appalling about the portrait of Judy Garland as a clown? Why do I react so violently? Why do I want to put a custard pie in her face? Why do I feel such horror at these clown portraits? What makes them so offensive?

Of course, clowns themselves are hateful. Clownophobia is something we learn when young. Clowns are grotesquely painted, terrifying, horrifying, mad people who come lurching toward us, threatening us, involving us. There is no fourth wall for these harpies of humor, no defensive screen for us to hide behind, to keep us safe from them, as in the movies. No footlights to protect us. They don't go on acting and behaving as if we weren't there, as in a play. Oh no, these people come at us. They know no boundaries. They remind us that we are here and so are they. Theirs is a world of chaos, filled with bullies—random instructions issued by potentially violent authority figures who will punish clowns at will, and to whom they respond with subversive, rebellious behavior. In short, they inhabit the world of childhood. They scare us because they are most like us; they are adults who behave like children. We have to be reassured by the laughter all around us that these lunatics are indeed non-threatening. We learn to participate a little in their madness,

in their worldview. We learn to laugh at them and through them to jeer at our tormentors. They are both cowardly and insanely fearless, and they ally with our sense of natural justice to encourage us to laugh at the tyrant, to mock the hypocritical, and to learn a healthy outlet for our fears.

"All very glib pop psychology, Eric," I hear you shout, "but what has all this to do with the price of fish?" Well, I have a vague theme lurking if you can put your slippered feet up for a moment and forget about your unanswered E-mail. *Fear.* Fear is what I associate with clowns, which is odd because most of my friends are clowns. Oh, they don't wear grotesque makeup and take pratfalls—well, except for Chevy—but professionally they are clowns. They go about the odd business of making strangers laugh for money. Actually, if I'm honest, one or two of them do strike a little fear into me, and I suppose I have to confess to being a clown too, since I spend my time vainly mocking a world I can't control. So what has this got to do with why I have always hated clown paintings?

Well, they *are* sentimental, appallingly sentimental, and any form of sentiment is anathema to an Englishman, since we are only permitted to feel emotion at the death of a Royal. But I actually ought to like these paintings. I am, after all, from Circus people, not just metaphorically as in *Monty Python's Flying Circus,* but in reality. My great-grandfather was a Circus Ring Master. I have souvenir programs from Victorian days, printed on silk, announcing a "Special Command Performance of John Sangers and Sons Circus on Thursday January 8th 1885 at Sandringham to celebrate the Coming of Age of H.R.H. Prince Albert Victor, Eldest son of The Prince and Princess of Wales, featuring Comical Hat Throwing and Amusing Chair Performance by the Clowns W. and J. Harvey," and announcing that George Foottit will "be transformed into a blushing Damsel, and imitate a Lady Equestrian." Or there is Wulff's Great Continental Circus, in Dublin on April 29, 1893, which advertises "Mirthful Moments with the Merry Clowns—sixteen in number," and underneath in the credits is my great-grandfather's name: "General Manager....Henry Bertrand." The General Manager was a big deal in the Circus. He booked the shows, paid the company, and then appeared under the Big Top as The Ring Master in his distinctive uniform of long red jacket, white riding breeches, and an impressive black topper. I have his printed notepaper, which bears an imposing picture of him in white tie and tails, proudly announcing the acts he represents, including my favorite, Robey's Flying Midgets.

When I was a child, my great-uncle, also called Henry Bertrand, took me backstage at Bertram Mills Circus in Manchester. There, amidst the sawdust and the tinsel and the warm smell of horses, I met the clowns close up. I approached with fear, but they were nice to me, shook my hand, patted me on the head. I could see they were just old men with makeup on and funny accents. To my uncle they were very respectful, even obsequious. In the Circus we were Royalty. So I have every reason to like clown paintings. But I don't. I hate them.

Is it just me, or does anyone else feel violent?

I'm going to assume that at least three of you put your hands up, so here's my theory about why I hate clown paintings. *They're not funny.* The expectation of a clown painting is the same as the expectation of a

clown—that it will make you laugh. But it doesn't. Worse—it portrays the expected humorist in a pensive, even downright sorrowful state. The damn clown is crying. It's as undesirable as a fart at a funeral. As a naked model taking a dump. As a...well, you get the point. It is an unfulfilled expectation. Here we are recovering from our earliest instincts of fear, all prepared to laugh, and what's this? The entertainer is filled with grief. Oh, shit. What is the painting telling us? Clowns are real people too. They have feelings and emotions. Well, *duh.* Not only is this not surprising, it is not even *interesting.* It has all the moral weight of a *People* magazine article. It's like Anna Karenina interviewed by Joan Rivers—"Who are you wearing for the train, Anna?" It's a Barbara Walters world where we learn the real heartache behind the success. Watch the famous cry at nine.

Well, give me a break.

People in showbiz are not nice ordinary folk; some of them are nice, but none of them are ordinary; many of them are freaks, and a few of them are out-and-out ego monsters. They are all fucked up in one way or another, or *they wouldn't be in showbiz.* The only excuse for them is that they are good at what they do. If they were not, they would be intolerable. So, don't come telling me about the sad world of the clown: that's why they are in the circus; it's their form of therapy. They do it because they like it. It's not compulsory. I no more want to know about their personal feelings than whether my waitress is menstruating, or where Hamlet is dining after the show, or whether Laertes is his boyfriend, or whether he and Gertrude are fighting over dressing rooms. It is not in the remit of the job description. It is too much information.

You'll notice that it is often showbiz people who are portrayed as clowns. You don't get CEOs or Nobel Prize winners posing with red noses looking sorrowful—although now that I think of it, I bet Bill Gates has one. It's usually comedians and divas who are the worst. You can be sure Liza Minelli has clown portraits of herself, same for Michael Jackson. I bet Larry King does too. And Oprah. Beware, be very wary of anyone who permits clown portraits of themselves. They seek to control you. They demand your sympathy. Resist. It's egotistical, it's bad, and it's appallingly sentimental. Remember, the clown is a tyrant too. They are just as authoritarian as the people they supposedly mock. So don't go falling for this bullshit about the tears beneath the surface—you don't want to know what lurks beneath the surface; *that's why they wear all that shitty makeup.*

And, of course, it's death that lurks beneath the surface, as it lurks beneath our surface, that mocks our mockery that, Hamlet-like, taunts a dead clown with "Where be his jibes now?" Well, he's dead, Hamlet. Clowns die. Hamlet dies. We all die. But remember that in some cases death is a jolly good thing.

OK. Rant over, slippers off, answer your E-mail.

ERIC IDLE

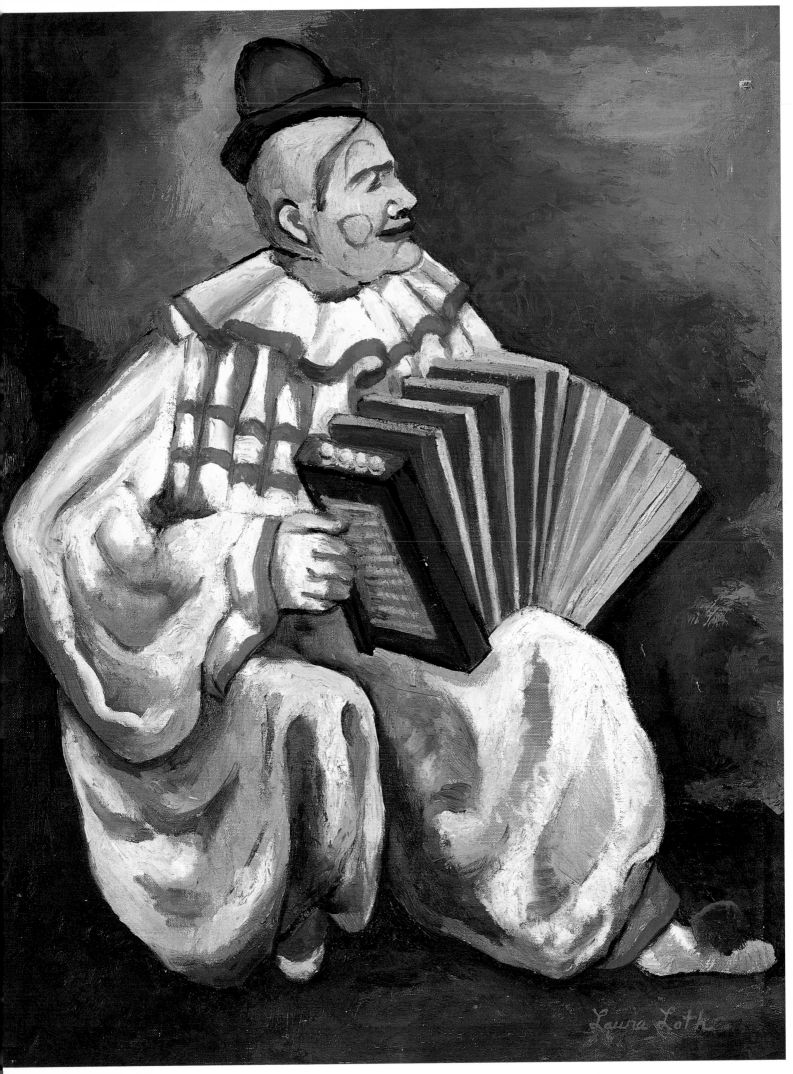

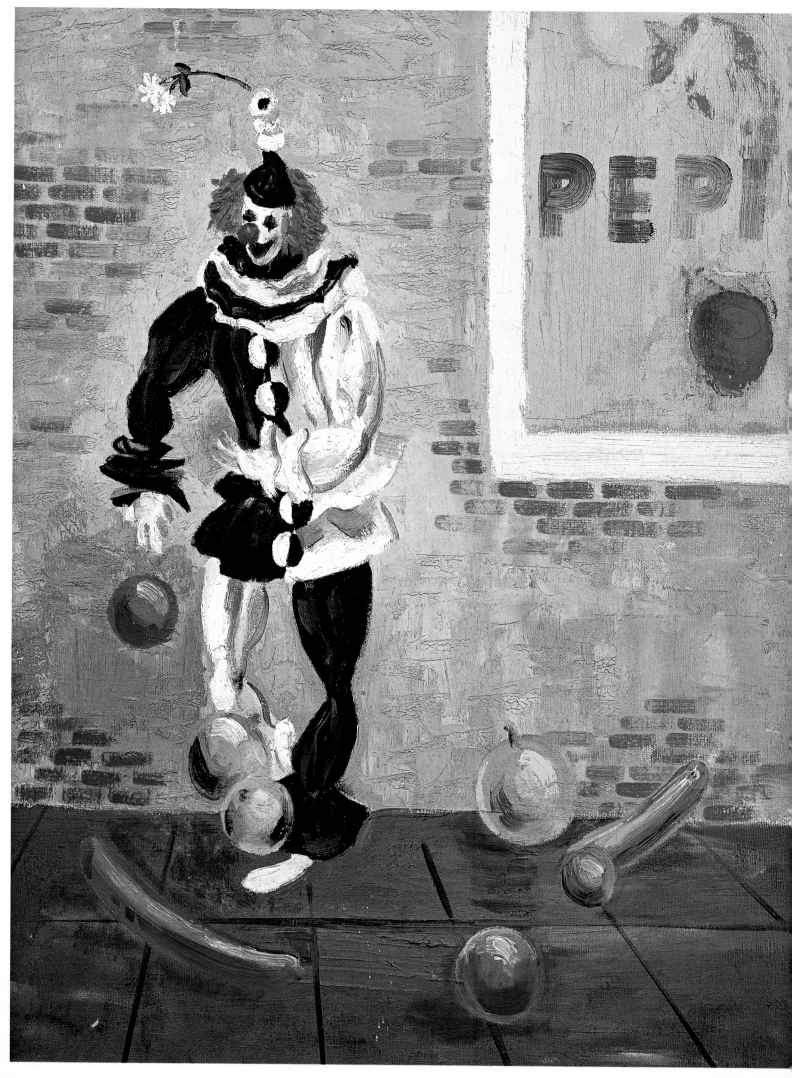

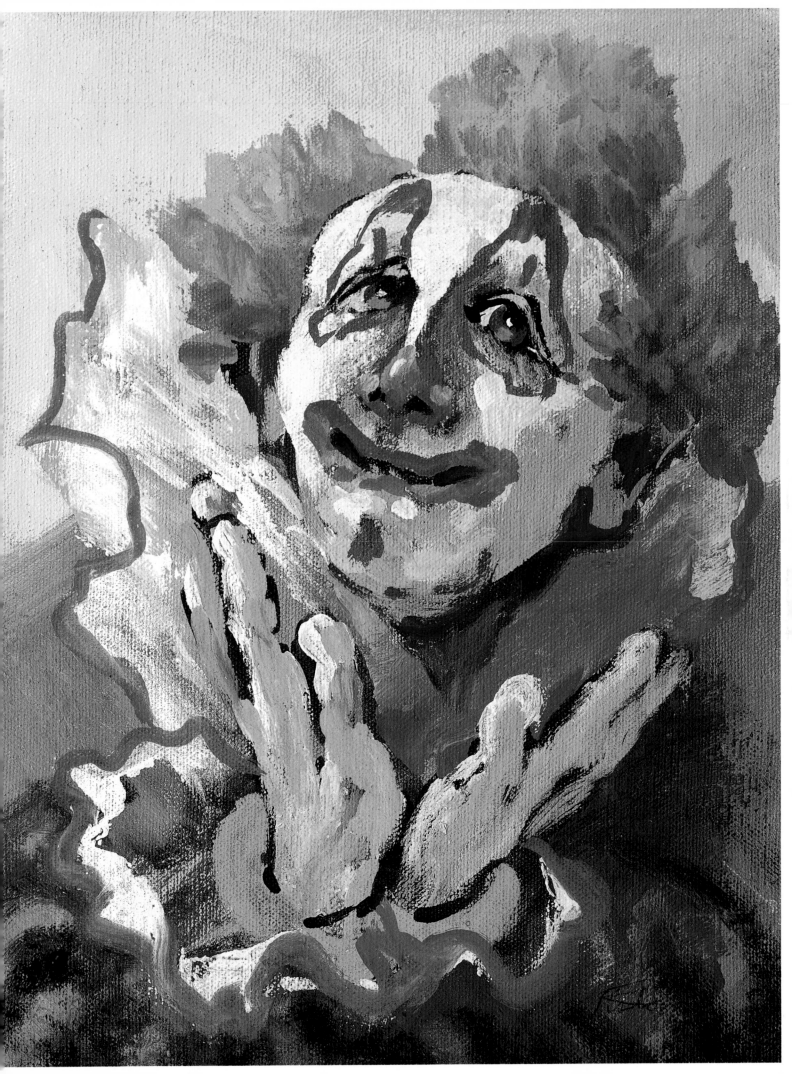

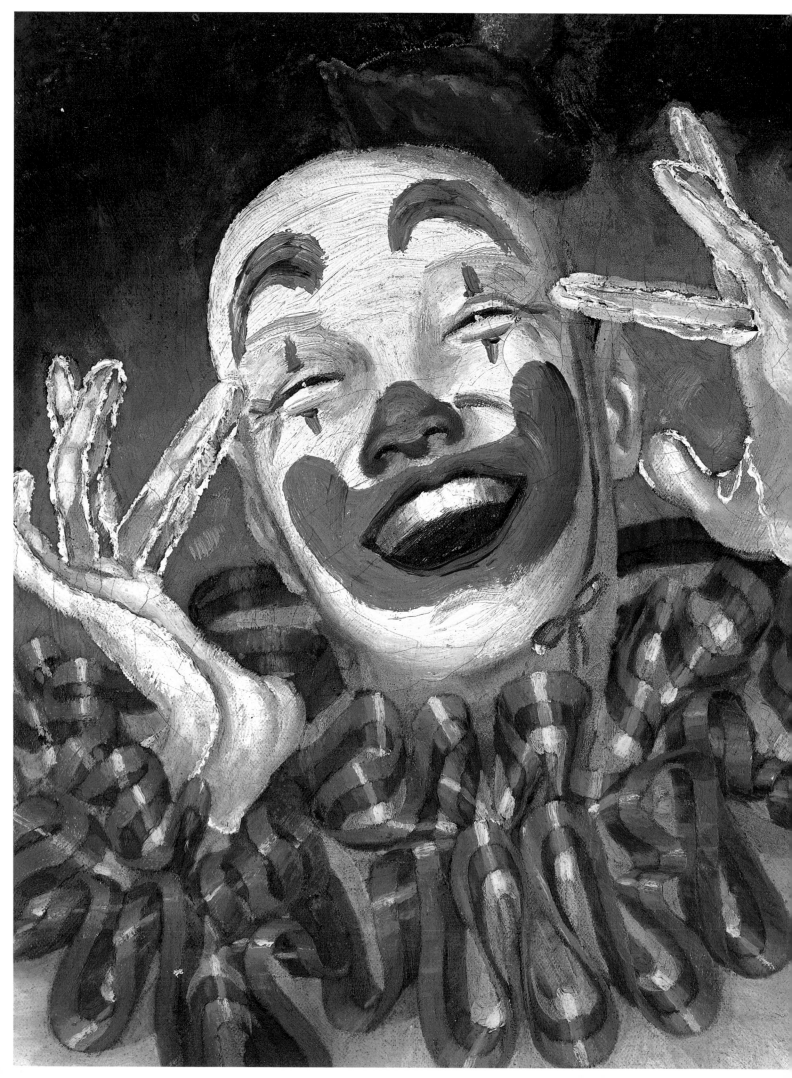

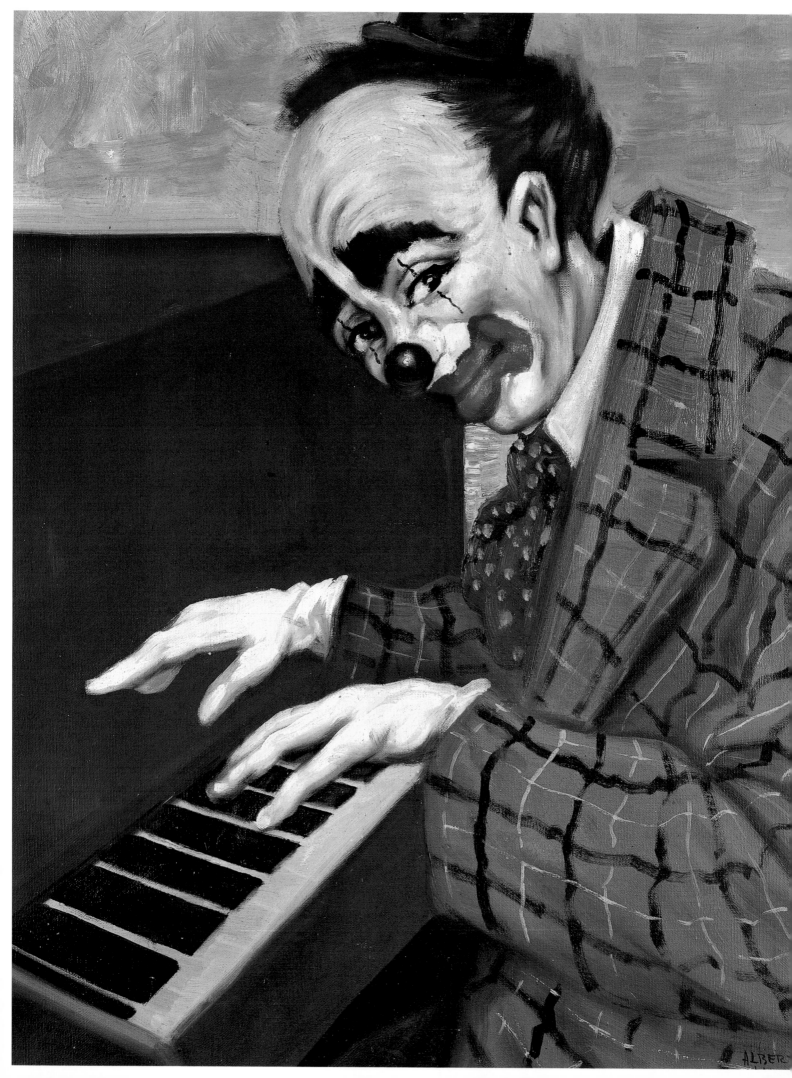

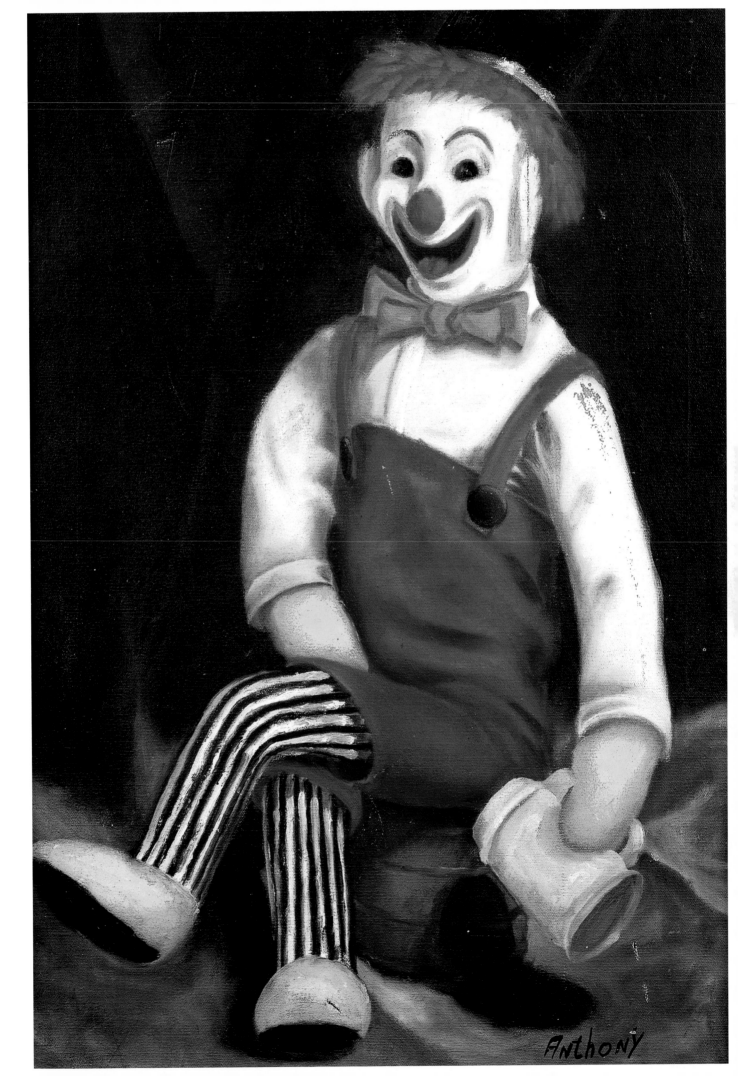

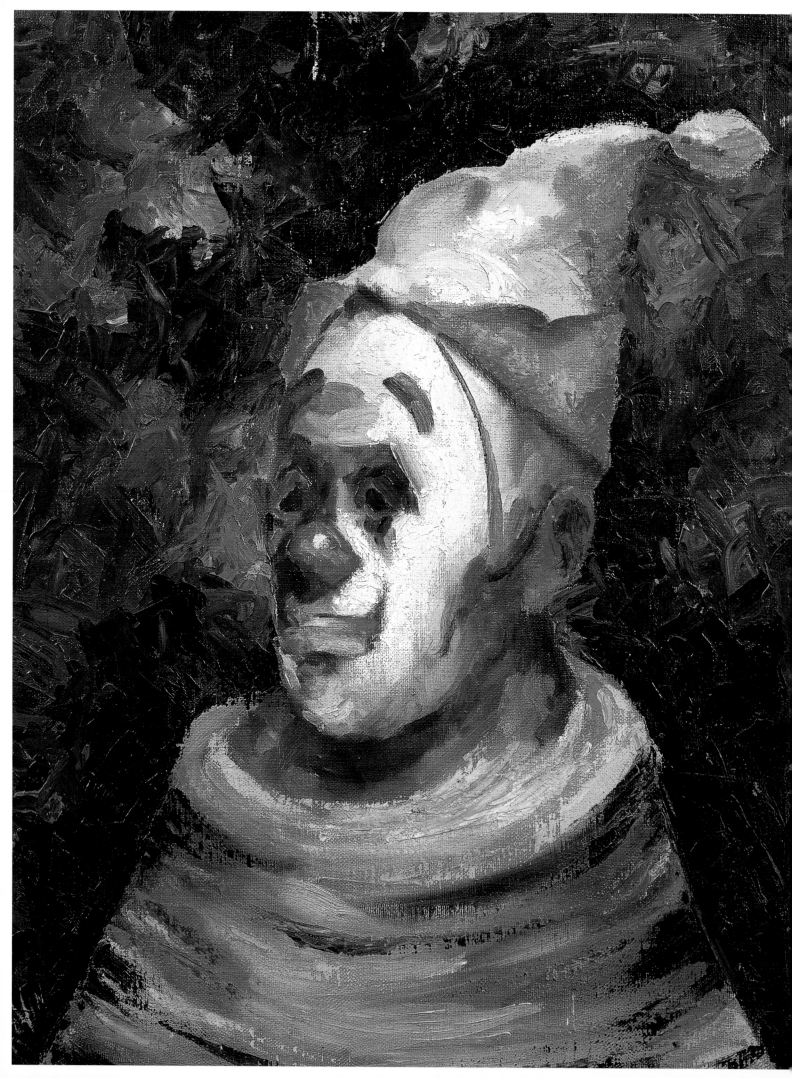

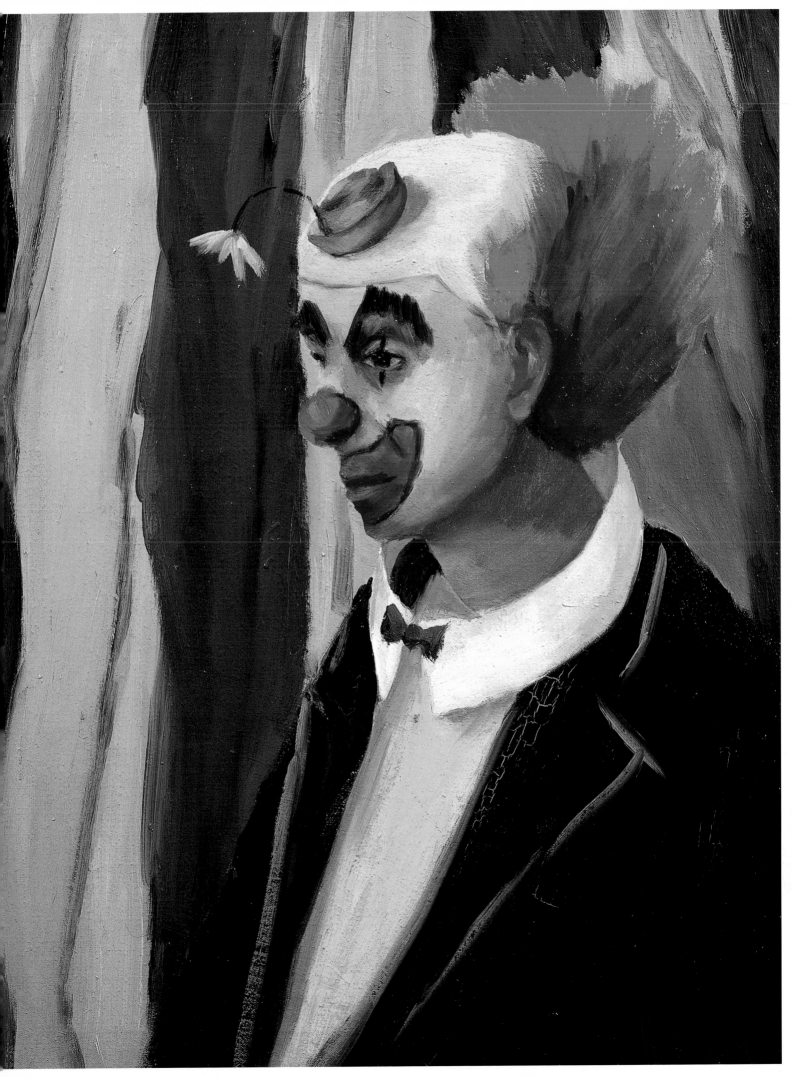

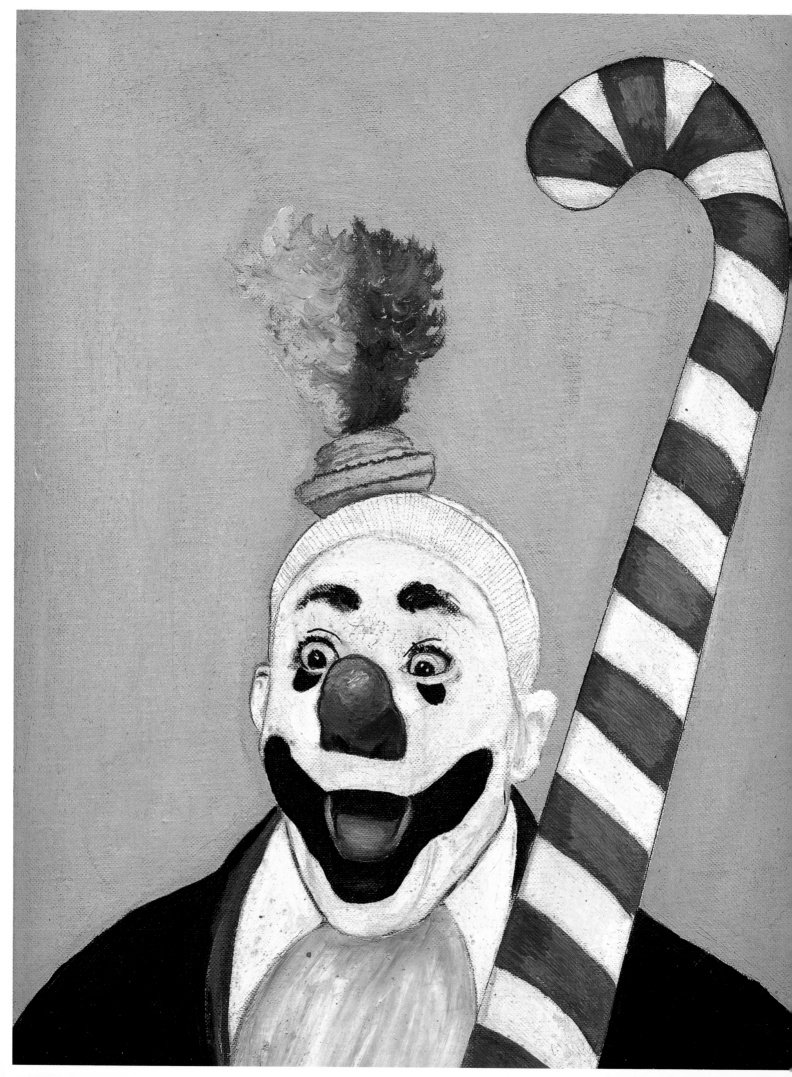

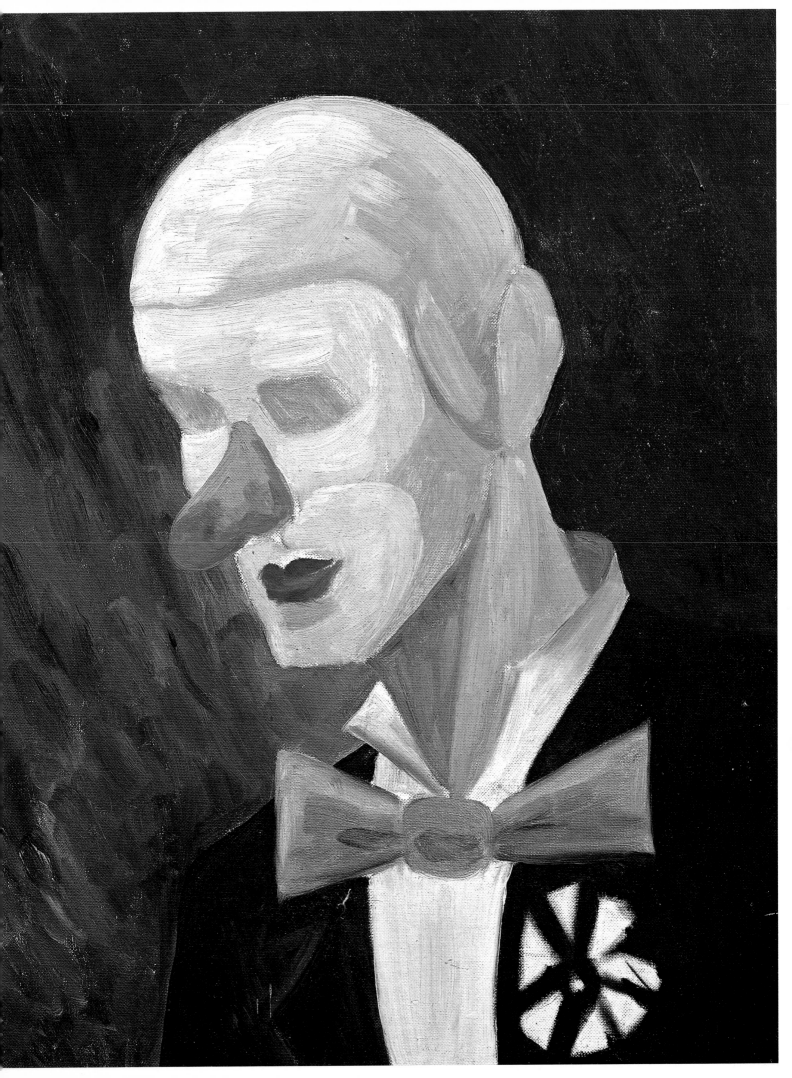

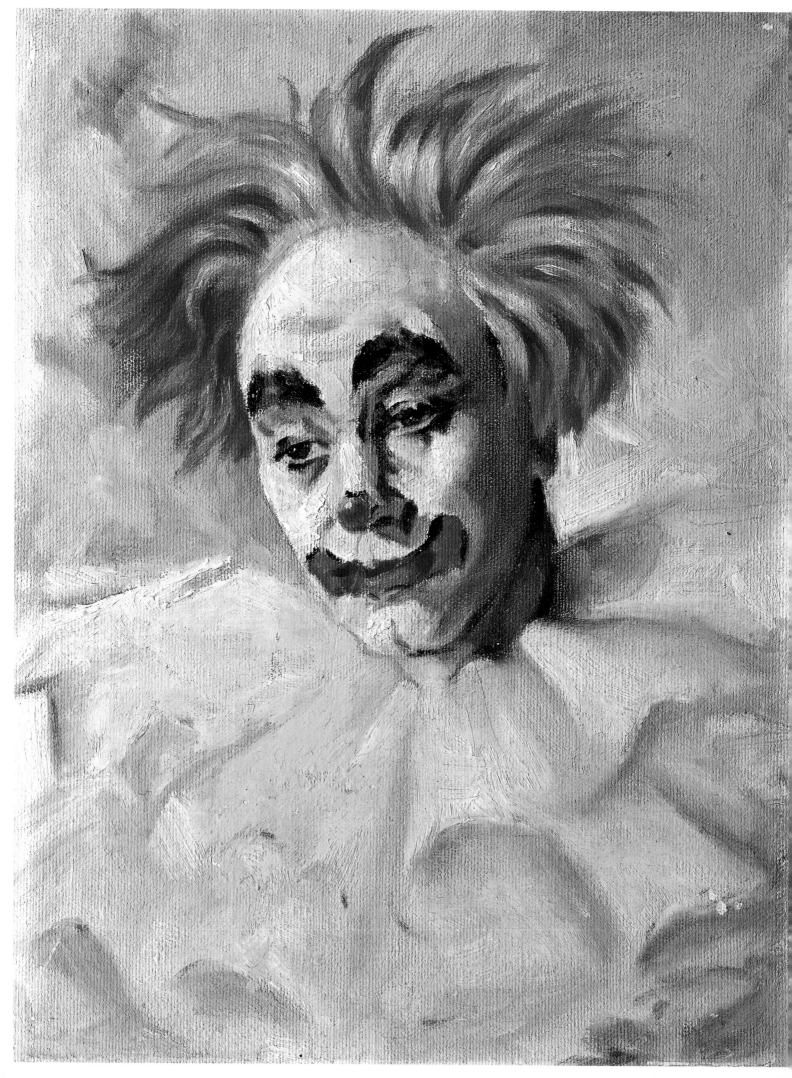

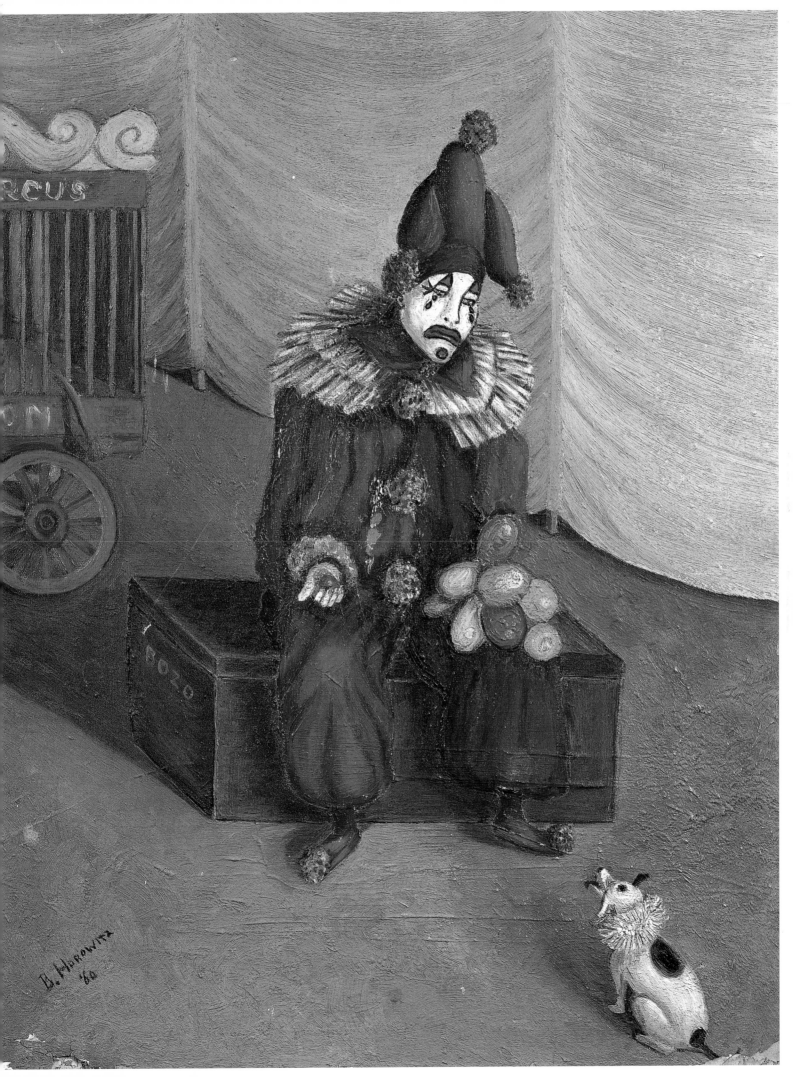

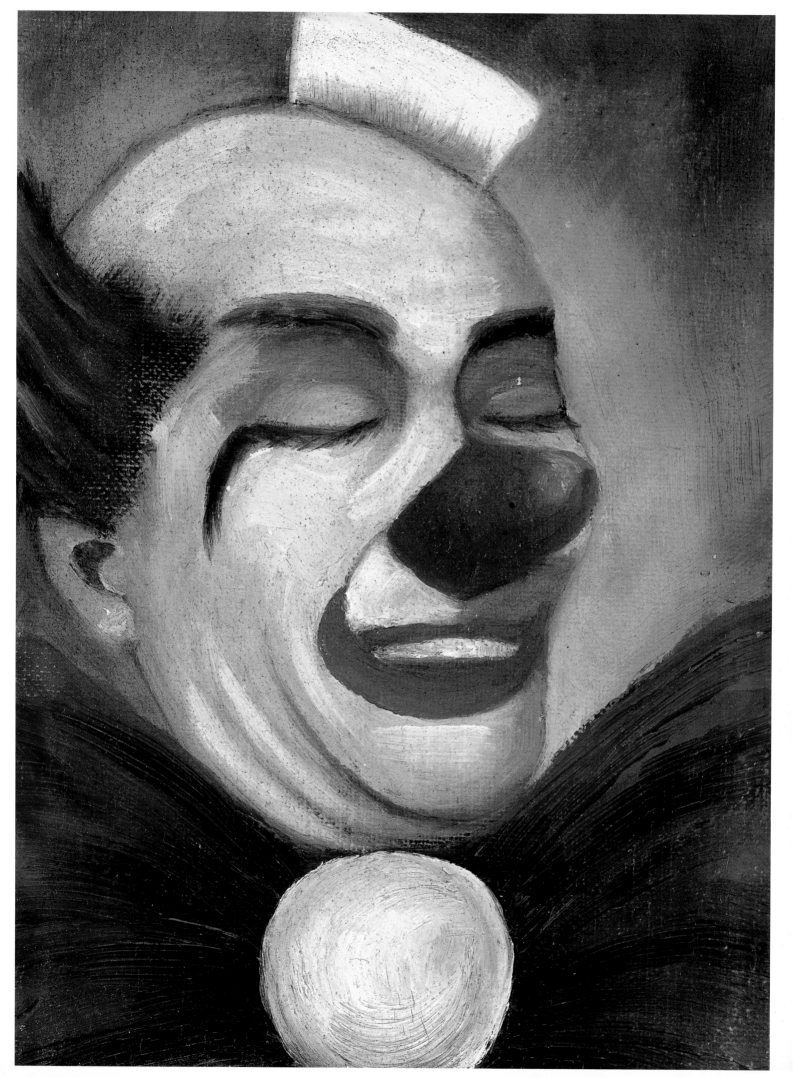

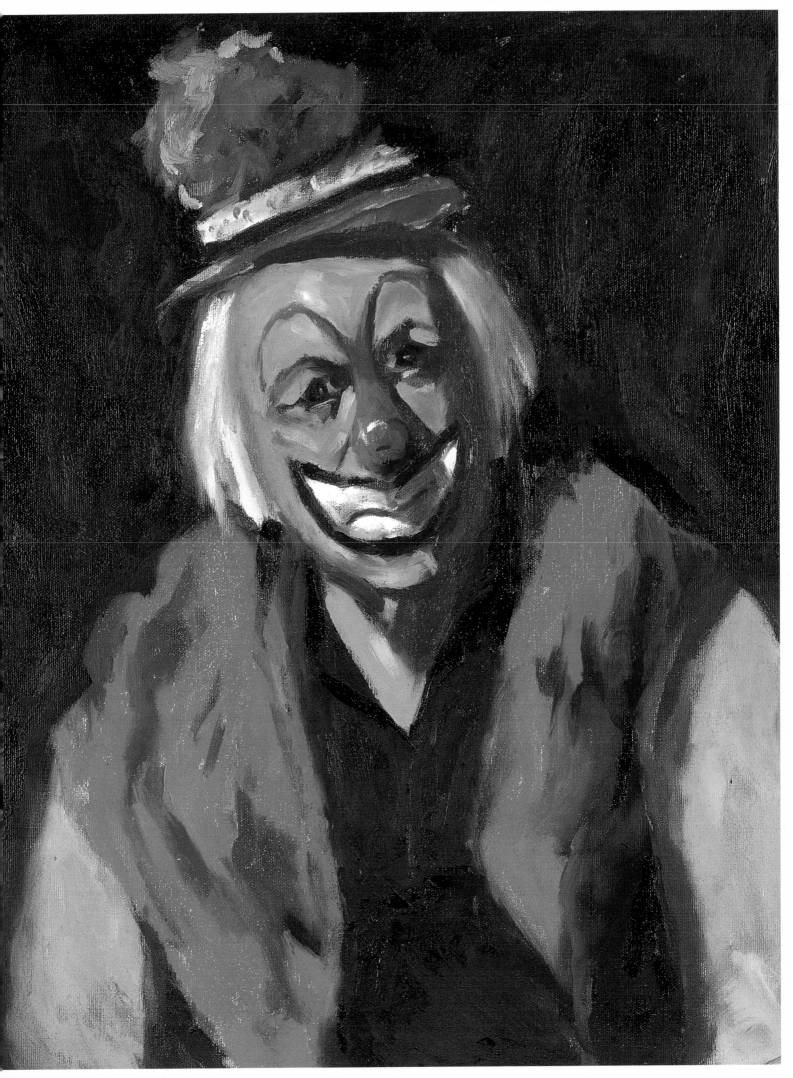

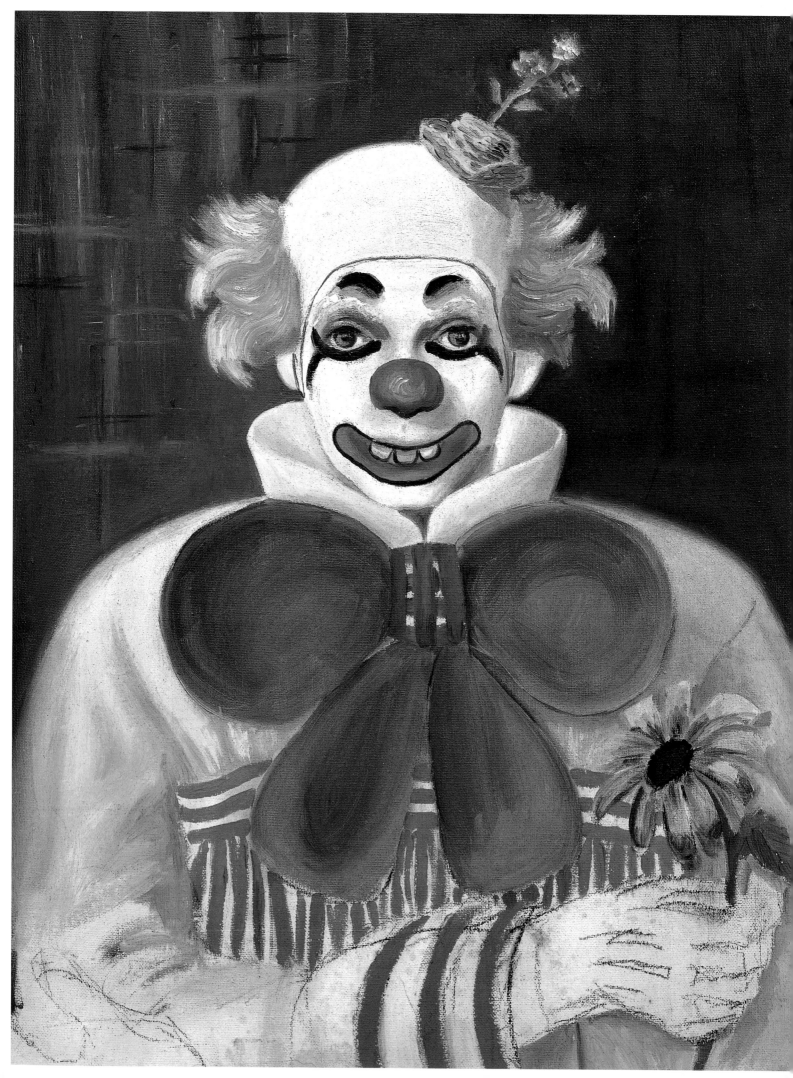

WHY CLOWNS? WHY NOT?

As an art dealer, the search for the extraordinary has led me down divergent paths. There is the joy of the hunt and the sell, but I also find a particular pleasure in collecting. By the nature of my work, I search for exceptional and rare art works on a regular basis. They say one man's trash is another man's treasure, and I have found both.

I have been collecting art for thirty years, and during this time have established specific criteria for choosing artworks. The same criteria apply to buying clown paintings—which I started collecting ten years ago—as apply to buying any other works of art. However, there are two critical differences between them. Generally, you can buy a very bad clown painting for the same amount of money you can buy, to my mind, a very good one. This is not always the case in the rest of the art world. And not everyone would agree that a painting of a clown is a work of art.

The premise of clown paintings is that they are "bad art," found in places where people recycle or throw away unwanted things: flea markets, yard sales, and thrift stores. So good clown paintings often end up in bad places, where only bad art is supposed to be, because of their price tags. In fact, it was in the early 1990s, while I was brokering the sale of a 1939 Man Ray painting of a harlequin to a major East Coast art museum, that I first spent a good deal of time deciphering the symbolism of clown paintings—how masks enable one to create a façade, how comedy is utilized to represent tragedy. Amateur artists exploit this

INDEX

All efforts have been made to identify the artists and seek permission to reproduce the paintings in *Clown Paintings*. Should additional information become available, it will be included in future editions.

★★ (From the Collection of **DIANE KEATON**)
★★★ (From the Collection of **ROBERT BERMAN**)

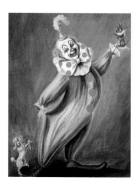

DON BREGMAN,
1956
14″ x 10″
★★★
PAGE 1

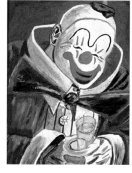

**FRED FREDDEN
GOLDBERG, ca. 1940**
20″ x 16″
★★★
PAGE 7

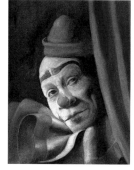

JOHN A. CONNER,
ca. 1950
24″ x 20″
★★★
PAGE 9

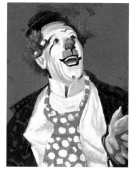

DON BARCLAY
19″ x 13″
★★
PAGE 10

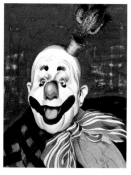

ALETHA MARTIN,
ca. 1950
20″ x 16″
★★★
PAGE 14

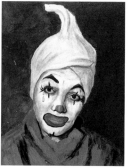

T. MOLLANDE,
ca. 1940
30″ x 15″
★★★
PAGE 15

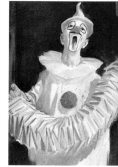

ALLIS
24″ x 18″
FROM THE COLLECTION
OF **DUG MILLER**
PAGE 16

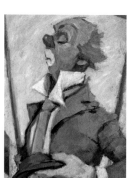

SIGNATURE ILLEGIBLE,
1959
20″ x 12½″
★★★
PAGE 17

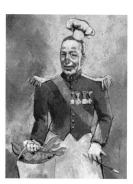

**JOHN PLUMER
LUDLUM, 1950**
36″ x 20″
★★★
PAGE 18

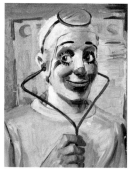

ARTIST UNKNOWN
20″ x 16″
★★
PAGE 19

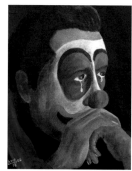

LUIS ENRIQUEZ, 1976
21″ x 18″
★★
PAGE 20

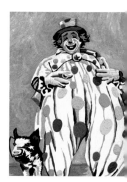

JOHNSTON
16″ x 12″
★★
PAGE 21

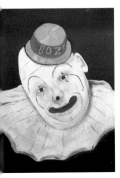

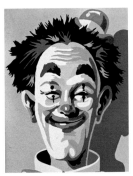

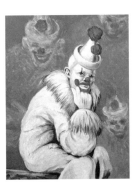

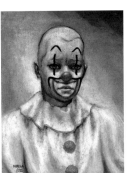

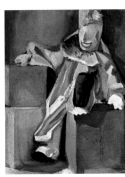

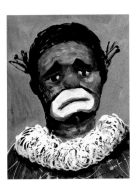

ALEX MANCUSO
24″ x 18″
FROM THE COLLECTION
OF **ROGER HANDY**
PAGE 22

ARTIST UNKNOWN
16″ x 12″
* *
PAGE 23

ROBERT E. GOODE
24″ x 18″
* *
PAGE 35

MAKELA, 1952
20″ x 16″
* * *
PAGE 36

ARTIST UNKNOWN
28″ x 22″
* *
PAGE 37

SMITH
15″ x 12″
* *
PAGE 38

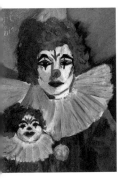

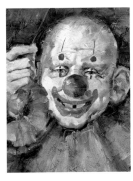

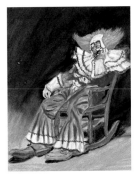

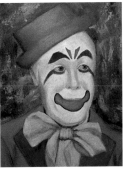

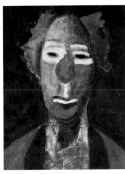

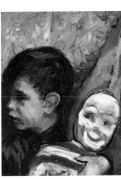

SIGNATURE ILLEGIBLE,
1961
16″ x 12″
* * *
PAGE 39

BARBARA WEBER
24″ x 12″
* *
PAGE 40

ARTIST UNKNOWN
16″ x 12″
* *
PAGE 41

ARTIST UNKNOWN
16″ x 12″
* *
PAGE 42

N. WEINER, 1957
16″ x 12″
* * *
PAGE 43

RALPH, ca. 1950
20″ x 24″
* * *
PAGES 44-45

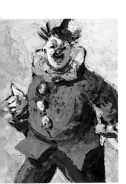

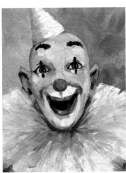

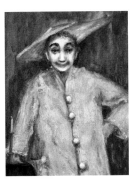

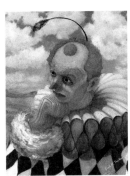

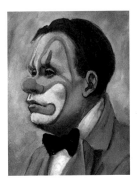

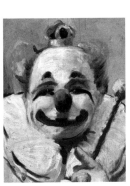

ARTIST UNKNOWN
15″ x 9″
* *
PAGE 46

A. DUBSKY
17″ x 14″
* *
PAGE 47

EESI, ca. 1950
16″ x 12″
* * *
PAGE 48

PAUL W. TUCKER,
ca. 1920
22″ x 18″
* * *
PAGE 49

ARTIST UNKNOWN
20″ x 16″
* *
PAGE 50

JESMUTZ
16″ x 12″
FROM THE COLLECTION
OF **STEVE MARTIN**
PAGE 51

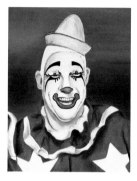

T. MESHER,
ca. 1950
20″ x 16″
* * *
PAGE 52

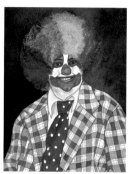

SHARON UHLIK
14″ x 11″
* *
PAGE 53

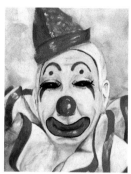

ARTIST UNKNOWN,
ca. 1940
19″ x 13½″
* * *
PAGE 54

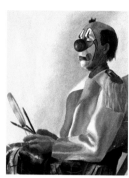

WATERS,
ca. 1950
10″ x 8″
* * *
PAGE 70

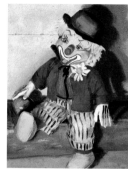

ARTIST UNKNOWN
22″ x 20″
* *
PAGE 71

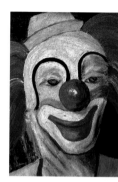

CONARD
11″ x 8″
* *
PAGE 72

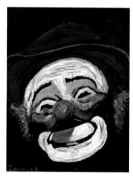

R. CHAKLES
12″ x 10″
* *
PAGE 73

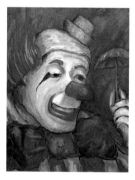

PAVAL
20″ x 16″
* *
PAGE 74

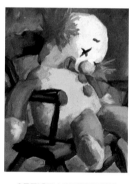

DENO SIDER,
ca. 1950
24″ x 20″
* * *
PAGE 75

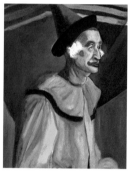

ARTIST UNKNOWN
18″ x 24″
* *
PAGES 76-77

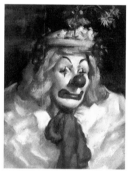

J. MORAN,
ca. 1940
32″ x 26″
* * *
PAGE 78

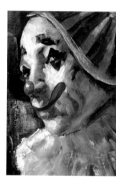

F. DRESSEN,
ca. 1930
16″ x 12″
* * *
PAGE 79

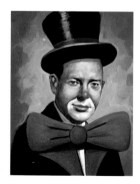

BORUTA
30″ x 24″
* *
PAGE 80

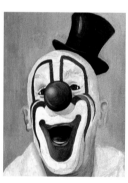

C. BLORE, 1959
24″ x 12″
FROM THE COLLECTION
OF **DUG MILLER**
PAGE 81

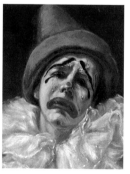

GALLEY,
ca. 1930
20″ x 16″
* * *
PAGE 82

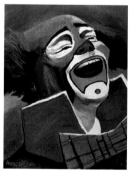

HENDERSON
10″ x 8″
* *
PAGE 83

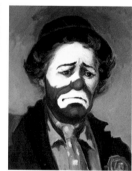

J. VALTOS, 1956
24″ x 18″
* * *
PAGE 84

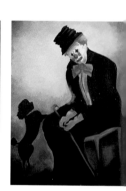

HELEN DAVIS
30″ x 24″
FROM THE CLOWN
BAR COLLECTION OF
DAVID KENDRICK
PAGE 85

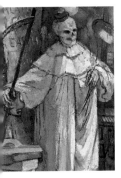
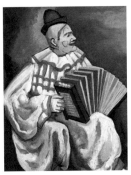
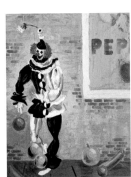
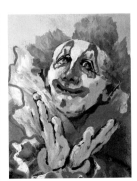
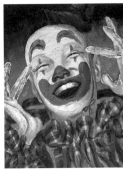
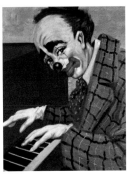

S. RUSHAKOFF, 1946
28″ x 20″
★ ★ ★
PAGE 86

LAURA LOTH,
ca. 1930
29¹⁄₂″ x 22³⁄₄″
★ ★ ★
PAGE 103

ARTIST UNKNOWN
24″ x 18″
★ ★
PAGE 104

ARTIST UNKNOWN
12″ x 9″
★ ★
PAGE 105

COLBOURN,
ca. 1940
14″ x 18″
★ ★ ★
PAGES 106-107

ALBERT VAL,
ca. 1940
24″ x 20″
★ ★ ★
PAGE 108

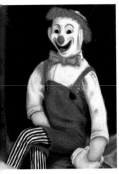
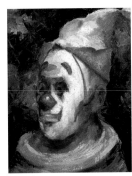
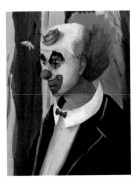
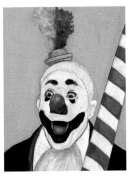
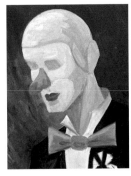
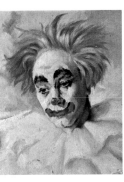

ANTHONY
30″ x 18″
★ ★
PAGE 109

KEVIN
20″ x 16″
★ ★
PAGE 110

KRUGER
24″ x 20″
★ ★
PAGE 111

ARTIST UNKNOWN
16″ x 12″
FROM THE COLLECTION
OF ROGER HANDY
PAGE 112

ARTIST UNKNOWN
20″ x 16″
★ ★
PAGE 113

ARTIST UNKNOWN
20″ x 16″
★ ★
PAGE 114

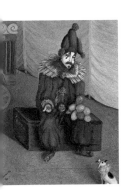
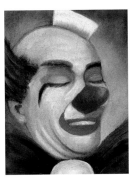
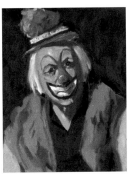
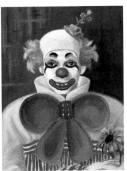
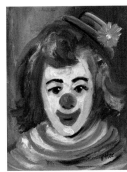
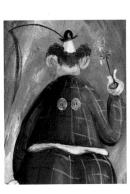

B. HOROWITZ, 1960
16″ x 12″
FROM THE COLLECTION
OF **ROGER HANDY**
PAGE 115

ARTIST UNKNOWN,
ca. 1950
7″ x 5″
★ ★ ★
PAGE 116

SIGNATURE ILLEGIBLE,
ca. 1950
24″ x 20″
★ ★ ★
PAGE 117

ARTIST UNKNOWN
20″ x 16″
★ ★
PAGE 118

V. HEE
16″ x 12″
★ ★
PAGE 127

LISI
30″ x 18″
FROM THE COLLECTION
OF **ROGER HANDY**
PAGE 128

THIS BOOK IS DEDICATED TO DORRIE HALL,
WHO CAN ALWAYS SPOT THE GOOD EVEN IN THE BAD.

DIANE KEATON, ROBERT BERMAN, and LOOKOUT thank the following people for their help and support: Maurice Berger, Lisa M. Berman, Jeff Carson, Erin Corzine, Douglas Denoff, Sam Denoff, Julie Dickover, Johnny Evans, Jeremy Favors, John Favors, Jonathan Gale, Linda Gershon, Jennifer Glianna, Larry Grobel, Roger Handy, Jim Heiman, Christine Jaspers, David Kendrick's Clown Bar, Steve Martin, Dug Miller, Donald Moffett, Andrew Novick, Janice Parente, Roger Rennick, Elena Ritchie, Bill Robinson, Steve Shadley, Jim Shaw, Dani Tull, Lou Valentino, Sara Willens, Daniel Wolf, and all the unknown clown painters.

CLOWN PAINTINGS

Published in the United States by powerHouse Books,
a division of powerHouse Cultural Entertainment, Inc.
180 Varick Street, Suite 1302, New York, NY 10014-4606
telephone 212 604 9074, fax 212 366 5247
e-mail: clownpaintings@powerHouseBooks.com
web site: www.powerHouseBooks.com

First edition, 2002

Library of Congress Cataloging-in-Publication Data:

Clown paintings / [compiled] by Diane Keaton ; with texts by America's premier comedians including Woody Allen ... [et al.].
 p. cm.
 "A Lookout book."
 ISBN 1-57687-148-7
 1. Clowns in art. 2. Portrait painting—20th century. 3. Art, amateur. I. Keaton, Diane.

ND1329.3.C55 C58 2002
757--dc21

2002068432

Hardcover ISBN 1-57687-148-7
Separations, printing, and binding by Artegrafica, Verona

A complete catalog of powerHouse Books and Limited Editions is available upon request; please call, write, or clown around on our web site.

10 9 8 7 6 5 4 3 2 1

Printed and bound in Italy

Lookout
1024 Avenue of the Americas, New York, NY 10018
telephone 212 221 6463, fax 212 719 0377

Producers: MARVIN HEIFERMAN and CAROLE KISMARIC
Project Manager: AKIKO TAKANO

ASSOCIATE EDITOR: CAROLYN BARBER

DESIGNED BY ARTURAN [CONSORTIUM], CHINATOWN, NYC
ANDREW CAPELLI ★ INFO@ARTURAN.COM

PHOTOGRAPHY BY JOSHUA M. WHITE, CULVER CITY, CA

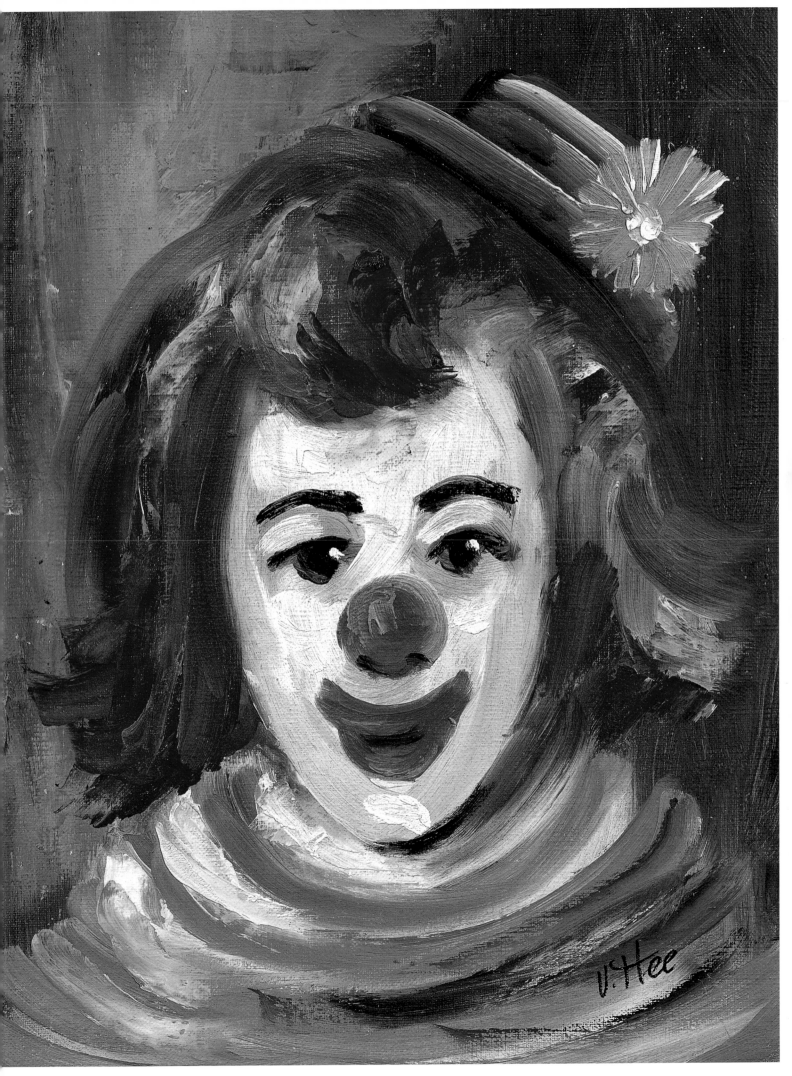

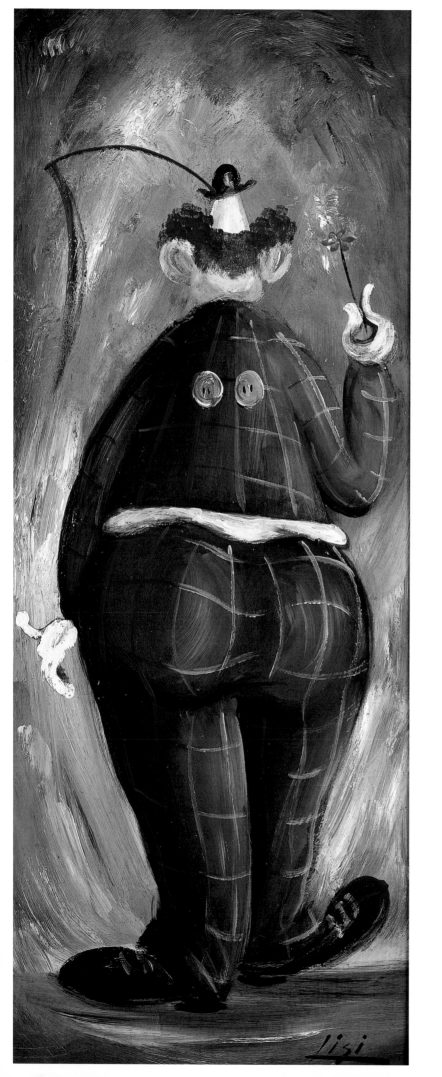